IMAGES
*of America*

# BORDENTOWN

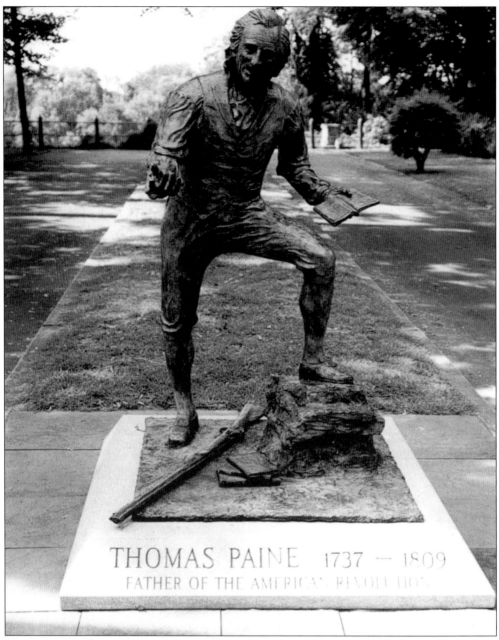

THOMAS PAINE 1737 — 1809
FATHER OF THE AMERICAN REVOLUTION

Thomas Paine, the "Father of the American Revolution," was a frequent visitor with his friend Colonel Kirkbride. He loved Bordentown so much that he purchased a house and property here, the only place in the world that he did so. Even during his years in France, he kept in touch with the people of Bordentown. He wrote to George Washington, "I had rather see my horse Button eating the grass of Bordentown or Morrisiana than see all the pomp and show of Europe." Paine wrote *Common Sense* and the *Age of Reason*. He also wrote *These are the Times That Try Men's Souls* to encourage the soldiers at Valley Forge. (Postcard courtesy of David Hoats, photographer.)

IMAGES
of America

# BORDENTOWN

Arlene S. Bice

*[signed]* Arlene S. Bice
19 Nov 2002

ARCADIA

First printed in 2002.

Published by Arcadia Publishing,
an imprint of Tempus Publishing, Inc.
2A Cumberland Street
Charleston, SC 29401

Printed in Great Britain.

Library of Congress Catalog Card Number: 2002110463

For all general information contact Arcadia Publishing at:
Telephone 843-853-2070
Fax 843-853-0044
E-Mail sales@arcadiapublishing.com

For customer service and orders:
Toll-Free 1-888-313-2665

Visit us on the internet at http://www.arcadiapublishing.com

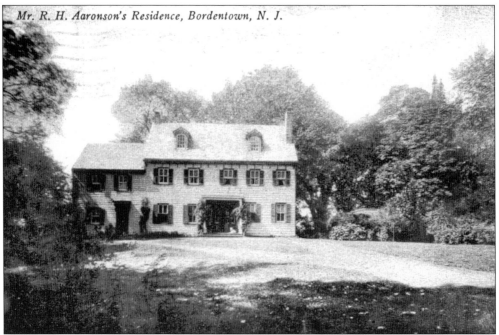

*Mr. R. H. Aaronson's Residence, Bordentown, N. J.*

This is the location, on a high bluff overlooking the area where Black's Creek and Crosswicks Creek empty into the Delaware River, that Thomas Farnsworth selected for his home. It is believed that the smaller portion of the dwelling, to the left, is the original house of Farnsworth. The intersection of Park Street and Prince Street is now in front of this property. (Author's collection.)

# CONTENTS

# ACKNOWLEDGMENTS

The first big thanks goes to Greg Taylor for his assistance in the research and editing, and thanks also go to Joe Horvath.

Many thanks go out to all of the people who have shared their wonderful memories and the treasures of their photographs. Each and every one was very important. A big thank you to Francis Glancey for parting with the history his father, James L. Glancey, recorded with his camera; to Bill Hensley, who recorded a later history with his camera; to Betty Ann Burke for all of the research she did and for the inquiries and copies she made; to Elsie and Sola Valentini for their help in identifying the people of their time; and to all of the folks too numerous to name here who brought in their stories.

A big thank you to Susan Jaggard, an editor at Arcadia Publishing, for her patience while walking me through this puzzle of the publishing world.

Aside from personal stories, the printed material I accessed are the following: *Bordentown Up-to-Date*, 1901; *Bordentown, Souvenir of Progress*, 1913; *Historic Pageant Souvenir*, 1917; *Bordentown's 250th Anniversary Souvenir*, 1932; *Bordentown, 1682–1932*, by James D. Magee; *Souvenir Program of the Bordentown Post Office*, 1939; *Souvenir of 275th Anniversary*, 1957; *Bordentown 1682–1976*, by the Bordentown Bicentennial Committee and the Bordentown Historical Society; *Patience Wright*, by Charles Coleman Sellers, 1976; and past issues of the *Bordentown Register-News*.

# INTRODUCTION

Bordentown seems to thrive under an umbrella of magnetism that draws people of integrity, creativity, ingenuity, and patriotism. It has long been a stopping-over place for visitors; many have returned to call Bordentown their home. In 1682, Thomas Farnsworth began purchasing acreage where the Black's and Crosswicks Creeks enter the Delaware River, eventually amassing 548 acres. After he made his initial purchase from the Quakers, he, of his own desire, paid the Leni Lenape.

By 1700, Farnsworth's Landing was busy with trading and shipping. After Farnsworth's death, Thomas Foulks bought the property on the bluff but held it for only four years, later selling it to Joseph Borden. Borden apparently had the same vision as Farnsworth and followed his example by buying the same acreage and carrying the idea further—he laid out a town plan with streets and dedicated property for churches. Because of its location, the area became a natural route between Philadelphia and New York. Passengers would come up the river, disembark at Bording's Towne, and take the stage on to New York City.

Bordentown was full of residents whose names were synonymous with patriotism. Thomas Paine, soldier and author; Francis Hopkinson, signer of the Declaration of Independence; Joseph Borden; Col. Joseph Kirkbride; and Patience Lovell Wright were a few of many in town who stood behind their beliefs in freedom and independence. Ben Franklin came as a visitor.

Bordentown was occupied by the British and Hessian troops under the command of Count Carl Von Donop, but even a British officer returned to buy a summer home in Bordentown after the war was settled. Joseph Bonaparte, former king of Spain and the Sicilys, made a new life for himself in the 20 years he lived here. Marquis de Lafayette, John Quincy Adams, Daniel Webster, Henry Clay, and Gen. Winfield Scott were visitors to his home. The "General" Mott of Civil War notability lived here. The talented writing, art, and music family of Gilder had a home in Bordentown. Richard Watson Gilder was the man to know in the publishing field of his time. Susan Waters, a famous pastoral artist, lived here, left, and returned to buy her old home back again. Another multitalented international group of artists, the Waugh family, had a mansion on the hilltop.

In the inventor and mechanical lines, Isaac Drips, who put together the first steam engine, the *John Bull;* John Rice, who invented the gasoline-powered rock drill; and George W. Swift Jr., who held hundreds of patents for his inventions, all made their homes in Bordentown. Yet, for all the changes that we have gone through in the last 320 years, we still have wonderful writers, artists, musicians, chefs, inventors, and patriots.

*This book is in memory of Angelo Falvo, barber on the main street, who loved this town as it loved him.*
—Arlene Bice

*To Bobbie and Donald, my current inspiration, and to "Gay Gay," my grandmother and the first author I had ever met.*
—Gregory Taylor

*To the memory of Orlo "Ray" Strunk, collector of Bordentown arts and memorabilia.*
—Joseph Horvath

# One

# EARLY YEARS

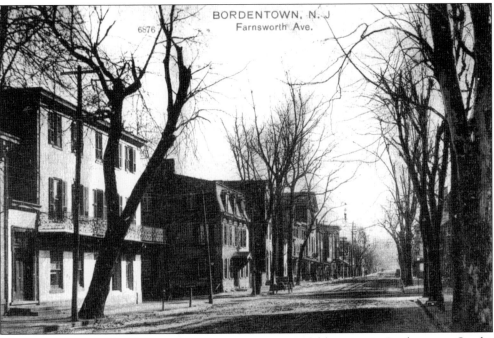

This intersection in the 1770s and 1780s was a very powerful location in Bordentown. On the left is Hoagland's Tavern. Col. Oakey Hoagland was the genial host of this tavern and public house. He was very active as a patriot during the Revolutionary War. Town meetings were casually held here before a city hall was built. On the other side of Market Street is the Francis Hopkinson House. Hopkinson was a signer of the Declaration of Independence. Across Main Street, unseen behind the trees, is the home of Col. Joseph Borden, who was also active in the rebellion against the king. Catty-corner from Colonel Hoagland's is the Patience Wright House. In the 1770s, Patience Lovell Wright—in her position as sculptor in King George's court—sent information hidden in her work for the patriots' use in the war. (Postcard courtesy of Gerry Young.)

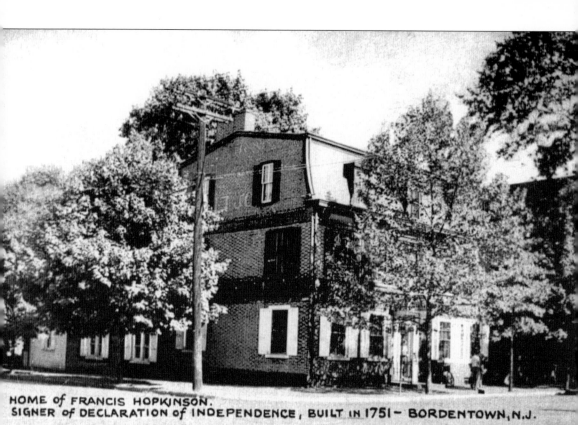

HOME of FRANCIS HOPKINSON.
SIGNER of DECLARATION of INDEPENDENCE, BUILT in 1751 – BORDENTOWN, N.J.

The Francis Hopkinson House, located on the southeast corner of Farnsworth Avenue and Park Street, was built in 1751 by John Imlay. Imlay kept a general store here until 1757. Francis Hopkinson was a delegate to the Continental Congress, signer of the Declaration of Independence, and one of three men selected for the first Continental Navy Board. He was also very talented as an artist and a musician. In this capacity, he created the state seal of New Jersey and designed the American flag. His talents included composing *The Battle of the Kegs,* a lyrical poem poking fun at the patriots' failure to blow up the British ships in Philadelphia harbor. A local story tells of the saving of the Hopkinson house when the British and Hessians occupied Bordentown during the American Revolution. Ann Hopkinson invited the British officers to dine. Seeing the extensive collection of books in the library and having a great respect for books, the chief officer spared the house. He did order that the Col. Joseph Borden House, which stood catty-corner from the Hopkinson house, be set afire. (Postcard courtesy of Gerry Young.)

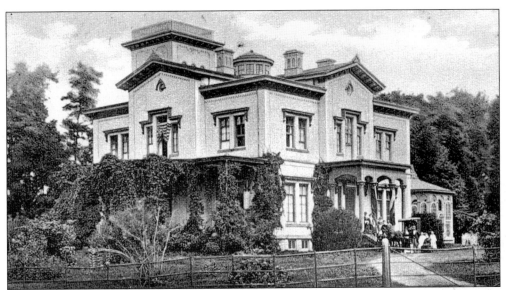

This photograph shows the Thomas Beckett mansion on the former Joseph Bonaparte estate. The king of Spain and Naples, brother of Napoleon, loved and lived in Bordentown for nearly 20 years. He named his vast estate Point Breeze. Marquis de Lafayette was a guest here, as were John Quincy Adams, Daniel Webster, Henry Clay, and Gen. Winfield Scott, among others. (Postcard courtesy of Debra Cramer.)

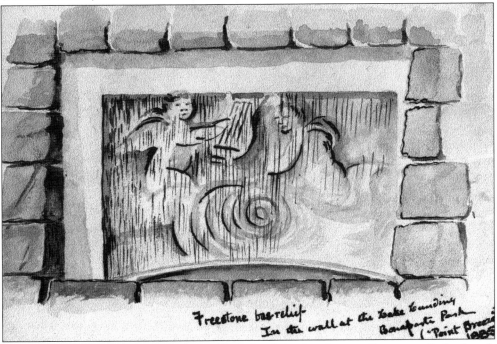

This freestone bas-relief was in the wall at the Lake Landing in Bonaparte Park. Joseph Bonaparte was used to being surrounded by the finest of material goods. When there was a fire in his mansion, the townspeople came and saved most of his artwork and fine furnishings and returned them to him when he came home from his travel. He was very impressed that average people would react in such a way. (Photograph courtesy of John McCoy.)

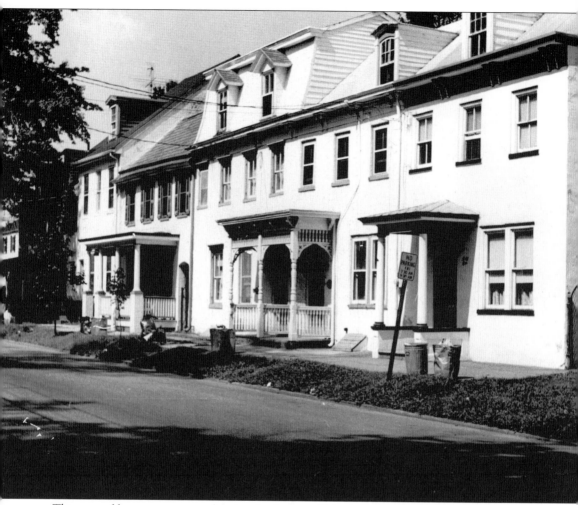

This row of houses was once the singular home of Major Frazer (British) of South Carolina, built for him after a visit to Dr. Burns, a friend. He decided to make this his annual summer residence. Prince Lucien Murat, son of Joachim Murat (king of the two Sicilys) and Caroline Bonaparte (sister of Napoleon and Joseph Bonaparte), met Caroline Georgina Frazer during one of these summer visits. After a whirlwind romance, the couple eloped to Trenton to marry, much to the dismay of her parents and his uncle Joseph Bonaparte. After they recklessly spent all of their money, Madame Murat and her two sisters opened a resident and day academy for young ladies. They called it Linden Hall. The school was very successful. The prince and his wife eventually returned to Europe to live. (Photograph courtesy of Larry Gordon.)

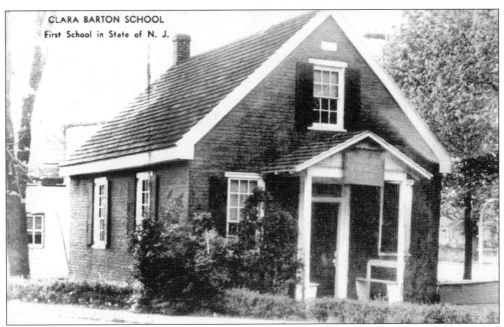

CLARA BARTON SCHOOL
First School in State of N. J.

Bordentown has been known for its many fine educating institutions. Various private schools have been available since the early 1700s. The first public school in New Jersey with continuity was in the Clara Barton Schoolhouse. It has since moved from the southeast corner of Farnsworth Avenue and West Street to its present location at Crosswicks and East Burlington Streets. (Postcard courtesy of Gerry Young.)

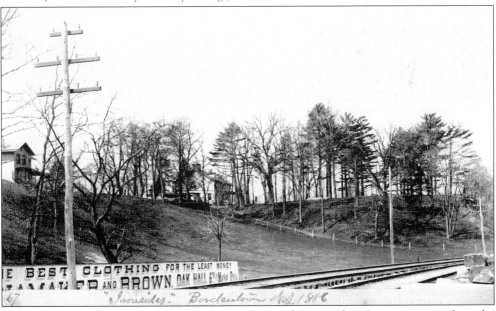

This unusual 1886 view is of Old Ironsides, the home of Commodore Stewart, as seen from the bottom of the hill where the railroad tracks run along the Delaware River. He was the captain of the USS *Constitution*, "Old Ironsides," for over 50 years. His daughter Delia married the Irish patriot John Parnell. Their son Charles Stewart Parnell became a famous Irish statesman. (Photograph courtesy of John McCoy.)

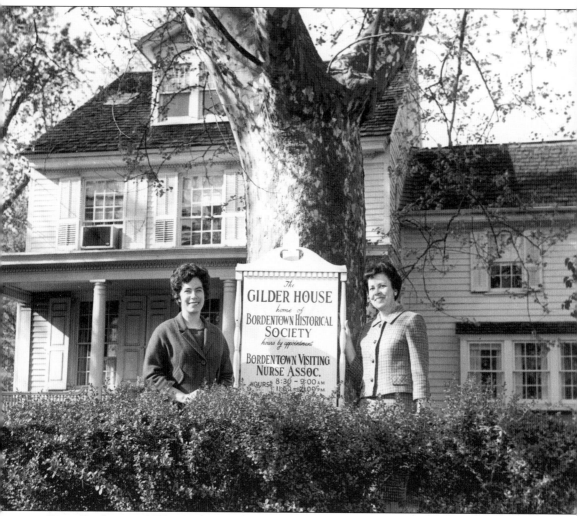

Susan Bradman and Ellen Wehrman display a newly painted sign of the Bordentown Historical Society and the Bordentown Visiting Nurse Association in front of the Gilder House. The Gilder family donated the historical house to the city in 1935. The city refurbished it and opened it to the public in 1940. The Bordentown Historical Society has furnished the interior with period antiques and paintings of past famous artists of Bordentown. They also open the house for tours. (Photograph courtesy of Bill Hensley, photographer.)

# Two

# EDUCATION
# AND WORSHIP

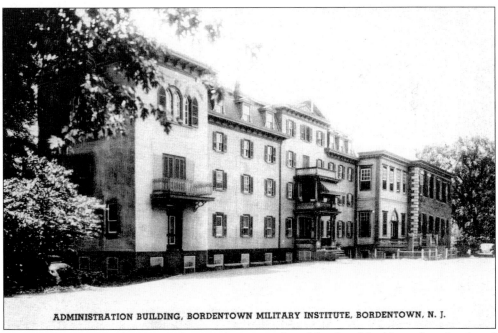

ADMINISTRATION BUILDING, BORDENTOWN MILITARY INSTITUTE, BORDENTOWN, N. J.

In 1837, Arsene Napoleon Girault, a professor, purchased land and buildings from his friend Joseph Bonaparte and founded the Spring Villa Female Seminary. He operated the school until 1842. In 1881, Rev. William Bowen purchased the building and reopened it as the Bordentown Military Institute. Col. Thomas H. Landon took the helm in 1885, and the school escalated in scholastic reputation. (Postcard courtesy of Gerry Young.)

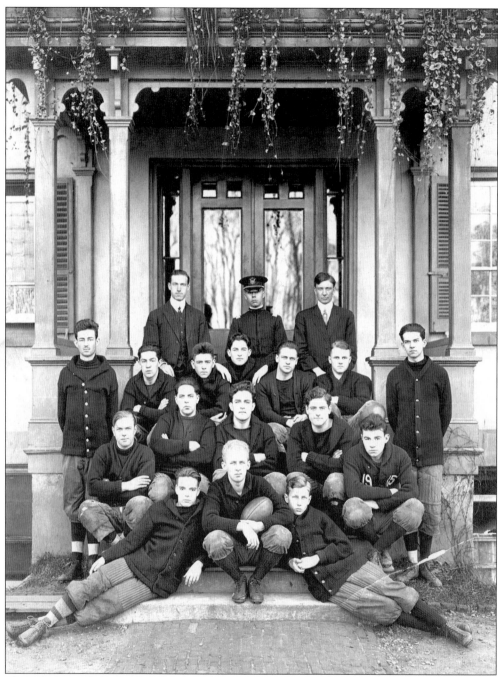

This photograph from 1915 shows the football team at the front entrance of Bordentown Military Institute (BMI). The cadets organized their first football team in 1887 and played the Peddie School. The baseball team was formed a year earlier. The winter brought out the hockey players. Track and gymnastic competitions began in 1896, and the sport of tennis became popular in 1900. Other clubs offered at BMI, as it was familiarly known, were bicycling, dance, basketball, bowling, cross country, quoits, rifle, soccer, wrestling, and winter track. The football team had 12 undefeated seasons between 1904 and 1963. (Photograph courtesy of Eric Gibbons.)

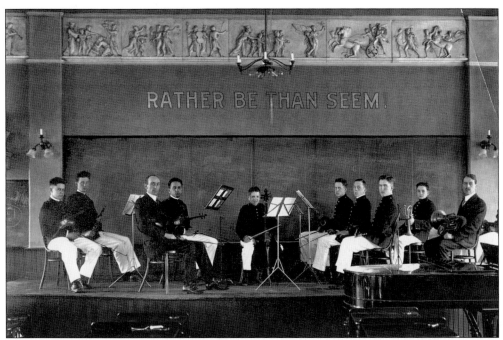

Courses offered to the cadets included academic, college preparatory, commercial, drawing, music, and science. Many students went on to West Point or Annapolis to become honor students there also. A daily reminder, their motto "Rather Be Than Seem," is printed across the wall where the music students are practicing. The school held dances and formal affairs. They also participated in all the parades in Bordentown. (Photograph courtesy of Eric Gibbons.)

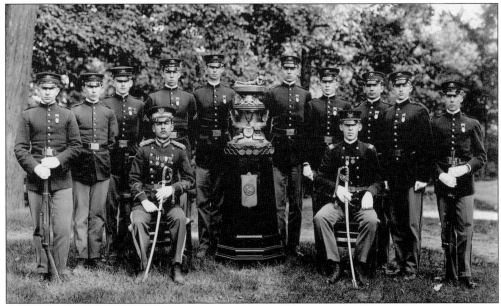

Sabers drawn and rifles displayed, the cadets from Bordentown Military Institute depict pride in accomplishment. The team, shown here around the full-size trophy, compiled outstanding records. The years 1913, 1914, 1944, 1948, and 1966 found the cadets winning national championships. (Photograph courtesy of Eric Gibbons.)

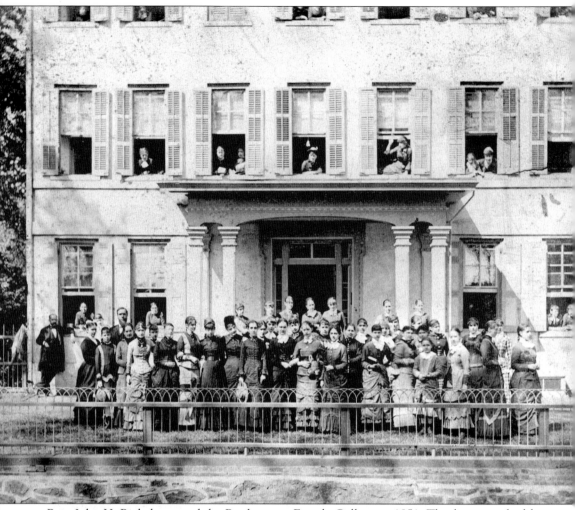

Rev. John H. Brakely opened the Bordentown Female College in 1851. This became a highly acclaimed school that was incorporated and conferred degrees. Many of the teachers came from New York. A memorial fountain, sculpted by Richard Thomas, still stands where Crosswicks Street meets Farnsworth Avenue. During the Civil War years, the girls of the college made American flags by hand and presented them to each Bordentown volunteer. Reverend Brakely and his family lived in the lovely Victorian house across the street. He also owned a canning factory on Second Street. His only son, J. Turner Brakely, eventually became a recluse and lived his life out at La-Ha-Way in the pinelands of New Jersey studying cranberry plants and flowers. (Photograph courtesy of Evelyn Seyebe.)

In 1885, the cornerstone of the St. Joseph's Motherhouse and Academy was laid, and another boarding and day school for young ladies was started in Bordentown. Girls of all faiths were accepted even though the academy was a Catholic institution. Vocal and instrumental music was offered, as were painting, fancy needlework, academic, and commercial courses. Day students and boarding students were accepted, and the dormitories were on the top floor. (Photograph courtesy of Bill Hensley, photographer.)

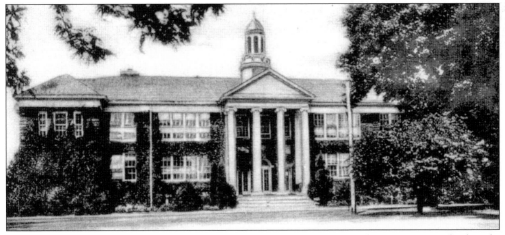

Rev. W.A. Rice, a former slave and a minister for the African Methodist Episcopal Church, established a private school in 1886 in a two-story house on West Street. The school prospered and was moved to a row of houses on Walnut Street. In 1894, the school came under the control of the state and moved to the Commodore Stewart property. It became known as the "Ironsides," as well as "Tuskegee of the North." The proper name was Manual Training and Industrial School for Colored Youth. The school had a fine reputation and a high degree of success for the education of black students that were boarded right at the school. (Photograph courtesy of Bettye Roberts Campbell.)

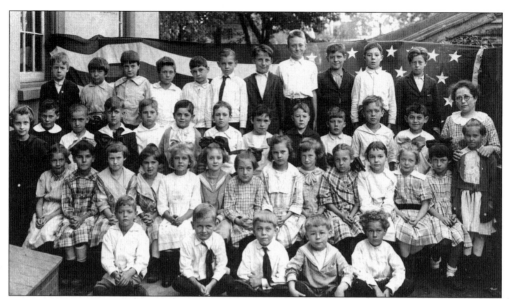

The giant American flag is the backdrop for the second and third grades of 1917–1918 of the Bordentown Public School. Miss Havens, the teacher, has her hands on the shoulders of Edith Rhubart Kafer. John F. Carty is in the front row, second from the left. In the second row, seated fifth from the left, is Christine Fithian Thompson. Eighth from the left in the same row is Harriet Thorn Madden. (Photograph courtesy of Christiana Carty.)

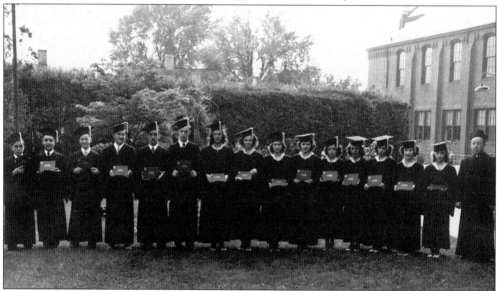

The proud students graduating from St. Mary's School on Elizabeth Street in June 1948 are, from left to right, Richard Haines, Raymond Haas, Joseph Albertson, Robert Kelly, John Meyers, Edward McDade, Patsy LeJambre, Shirley McElhoes, Patsy Titcomb, Bunny Thorn, Margie Murphy, Mary Angelini, Virginia Henderickson, Mary Dunphy, and Betty Ann Burke. Father Lyons is seen on the right. Note that the boys are lined up on one side, and the girls are lined up on the other, as the two were kept as separate as possible in those days. The high hedge in the background has been removed and replaced with a parking lot. (Photograph courtesy of Betty Ann Burke.)

The Poor Clare Order was established in Assisi, Italy, in 1212 and in the United States in 1875. In 1909, the Poor Clares were invited to establish a monastery in the former Motherhouse of the Sisters of Mercy on Crosswicks Street. Five cloistered nuns and two externs responded from Jamaica Plain, Massachusetts. Poor Clares were a cloistered order, devoting themselves to silence, prayer, work, and sacrifice. They were a self-contained order. In the early years, they farmed the acreage behind the building and raised chickens, a cow, and goats. They sold eggs to the public through a lazy-Susan window and baked altar breads to supply the diocese of Trenton. The order has since moved to a modern building in a rural area. They have also modernized and adjusted their lifestyle. The monastery is presently an assisted-care unit. (Photograph by Bill Hensley, courtesy of John McCoy.)

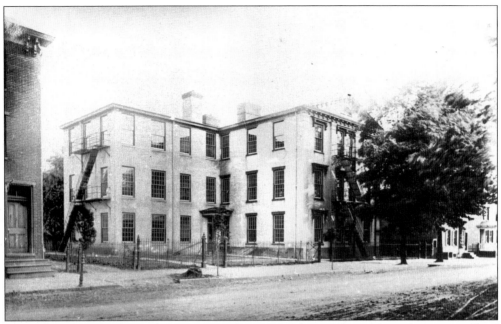

School No. 1 was built in 1852 on Crosswicks Street and opened in 1853 with a principal and four female assistants. The school originally had two floors consisting of four rooms. Additions were made in 1898 and 1908. This building served the community for 100 years. It was demolished in 1954. (Photograph courtesy of Larry Gordon.)

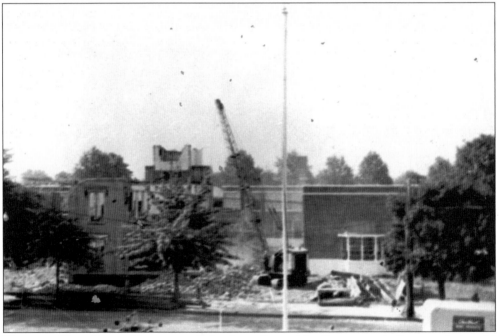

The new Clara Barton Elementary School on Crosswicks Street was built around the old School No. 1, shown here with just a bit of wall remaining. It made for a smooth transition; the new wrapping around the old. The front patio marks the site of where the old school stood. (Photograph courtesy of Larry Gordon.)

The people of Bordentown have always thought highly of their schools and have been very generous to them. In 1924, Howard Newell gave a valuable history of Burlington and Mercer Counties edited by the esteemed E.M. Woodward and John Hageman. In 1925, Richard C. Woodward presented a masterpiece by Susan B. Waters. The pastoral painting is of sheep, for which she was well noted. In 1936, Dr. William MacFarland donated an entire library to the Bordentown High School in memory of his father, William MacFarland, a professor, including a bookcase that came from the manor house of Joseph Bonaparte. Professor MacFarland was a former principal of the school and then superintendent of schools. The professor served the system for 26 years and was responsible for the first organization of the high school. In January 1942, a fire swept through the building. The damage was estimated at $150,000. (Photograph courtesy of Larry Gordon.)

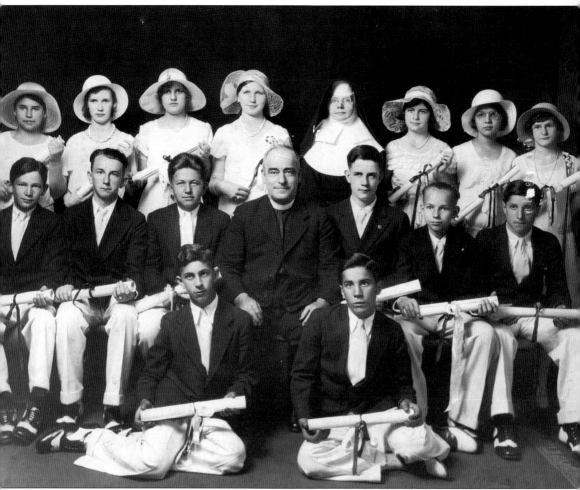

Rev. Edward J. Whalen was very active with the youth at St. Mary's School, installing activities for them. He was the pastor at the church from 1929 through 1944, when he died. He gave this photograph to his 1931 graduating class. Pictured here are, from left to right, the following: (front row) Babe Mercantini and George Spundarelli; (middle row) Jim McCusker, Dick Ratigan, Tubby Murray, Father Whalen, Jim Magee, George Latham, and Albert Eleutari; (back row) unidentified, Dorothy Stillwell, Ruth Bussom, Catherine Whister, Sister K. Burtmans, Mary Malone, Betty Haas, and Catherine Keeley. The class motto was "Onward and Upward." (Photograph courtesy of Gloria Spundarelli.)

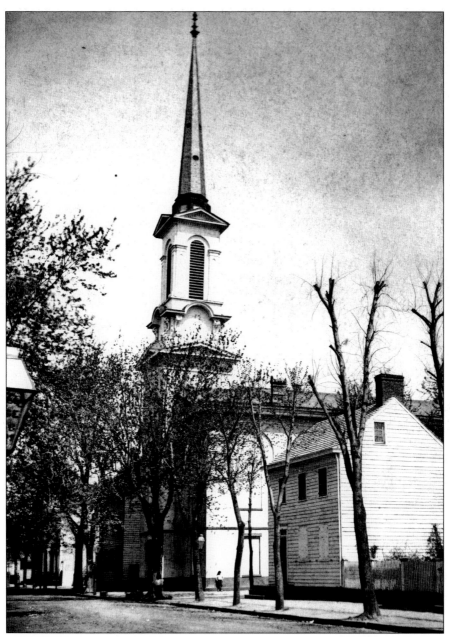

The First Baptist Church of Bordentown stood on Prince and Church Streets from 1861 to 1892, when the church steeple was struck by lightning. Dr. James Lisk was pastor. Baptists were worshipping in the area prior to 1751. At that time, Joseph Borden deeded two parcels of land for the sum of five pounds to members of a Christian congregation baptized by immersion. The house in the foreground was once the home of Thomas Frazer, formerly a British officer, husband of a wealthy plantation owner's daughter. His daughter Caroline Georgina married Prince Lucien Murat, the nephew of former Bordentown resident Joseph Bonaparte. After the prince spent her considerable fortune, Caroline converted their home on Park Street to a very successful and fashionable school for ladies. It was named Linden Hall. Today, it still stands, but as private residences known as Murat Row. (Photograph courtesy of First Baptist Church.)

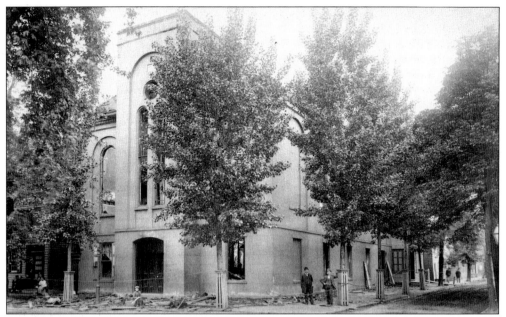

This shows the damage done to the First Baptist Church after the fire. On a May 1892 night, a terrible storm took place with heavy thunder and lightning. William Horsfull, walking toward his home at 11 p.m., saw the flames in the 176-foot steeple. He notified the men at Cain's Saloon and rang the fire bell at the Citizen Hook and Ladder Company on Walnut Street. (Photograph courtesy of First Baptist Church.)

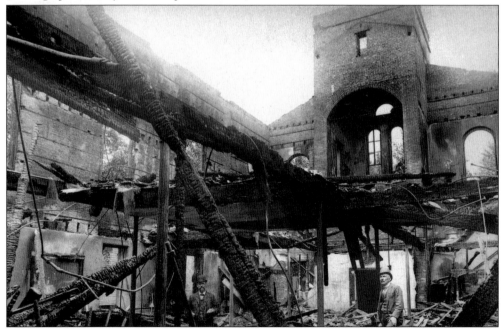

Alas, Bordentown equipment was not enough. Trenton responded by sending their steamer. But the Trenton hookups were New York style, and Bordentown's were Philadelphia style. Somehow they improvised, battled all night, and kept the fire from spreading to the surrounding houses and businesses. (Photograph courtesy of First Baptist Church.)

The first Episcopal services were celebrated by the Right Reverend George Washington Doane, the bishop of New Jersey, on December 23, 1833. The first building of Christ Episcopal Church, shown here, was erected in 1837 with later portions added on in 1839 and 1854. The large cast bell by Meneely Bell foundry was shipped down from New York and placed in 1855 and is the current bell in the steeple today. (Photograph courtesy of rector, wardens, and vestry of Christ Church.)

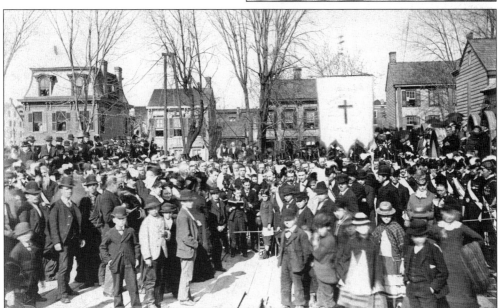

Approximately 3,000 townsfolk are dressed for the occasion to witness the laying of the cornerstone of the new Christ Episcopal Church in 1879. The marching band played, and a proper ceremony was held. Rev. Nathaniel Pettit, pastor of the church, and Bishop Right Reverend John Scarborough were in attendance. (Photograph courtesy of rector, wardens, and vestry of Christ Church.)

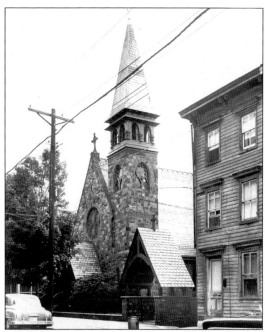

This *c.* 1950 view of the Christ Church includes the first house in a row of dwellings that was lined up alongside the church. Bordentown artist Edward R. Burke painted this area from the other side of the hill. The area was called Coconut Hill. The houses were later demolished to make way for a much-needed parking area. (Photograph courtesy of rector, wardens, and vestry of Christ Church.)

This children's Succoth party was held at B'nai Abraham Synagogue on Crosswicks Street in 1949. Seated are, from left to right, Philip Goldman, Louise Reichlin holding Phyllis Busch, Marion Weisman, Andrew Smulian, Martha Mall, Janice Leary, Jay Lapin, Jeffrey Goldman, unidentified, Francine Kanter, and unidentified. Standing are, from left to right, Peter Reichlin, Robert Glick, Warren (Fred) Leary, unidentified, Jack Kimmelman, and Vicky Gutstein holding Zelda Goldman. (Photograph courtesy of B'nai Abraham Synagogue.)

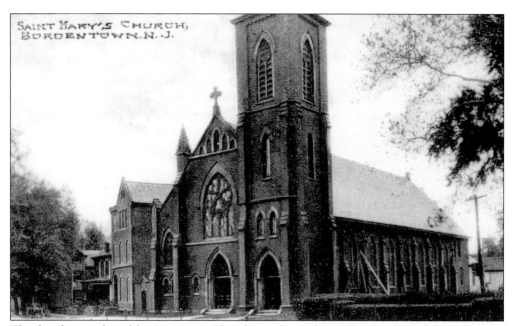

The first lot purchased by St. Mary's Church was located at Second and Bank Streets. John Flynn acted as agent for Father Mackin in 1841. The cornerstone was set in 1870 at the new church on Crosswicks Street. The church was built on an angle from the street line because there was not enough money at the time to purchase the adjoining property. (Postcard courtesy of Gerry Young.)

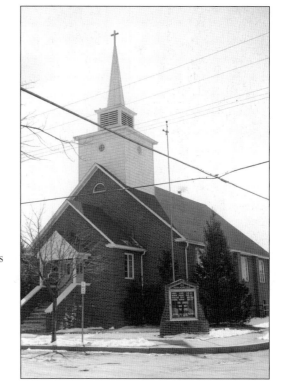

The Union Baptist Church has gone through several changes and improvements since its beginning in 1935 under the guidance of Rev. Joseph Nelson. The congregation first worshiped at Masonic and Knights of Plythian Hall before purchasing property at 364 West Burlington Street. It was a happy day for the parishioners. (Photograph by Bill Hensley, courtesy of John McCoy.)

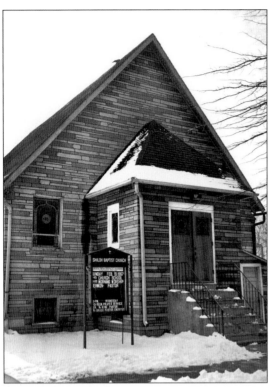

Rev. William Bragg organized the Shiloh Baptist Church, starting with eight members, in 1917. The meetings were held at the Junior Mechanics Hall on Crosswicks Street. In 1923, the cornerstone was laid for the new church on East Burlington Street. Bragg remained its pastor for at least 40 years. (Photograph by Bill Hensley, courtesy John McCoy.)

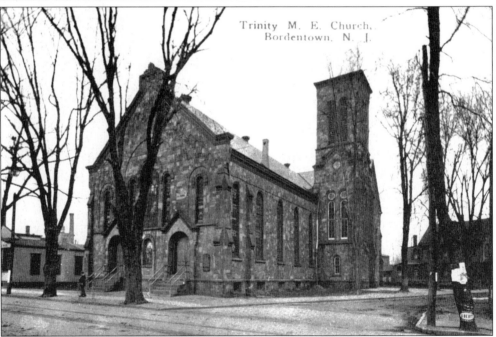

The postcard shows the Trinity United Methodist Church as it stood at an earlier time. The first resident pastor was Rev. John L. Gilder. Notice that this was printed before the First National Bank was built to the left in 1914. The Honor Roll installed in 1944 stood between the bank and the church. (Postcard courtesy of Gerry Young.)

# Three
# CITY AND GOVERNMENT

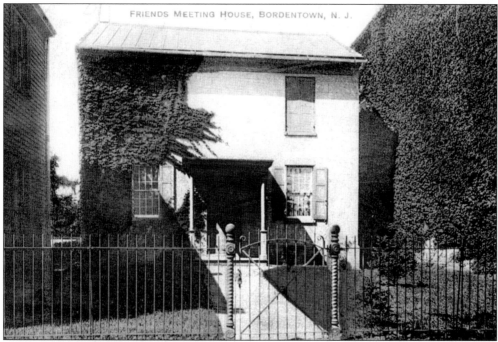

The Society of Friends, or Quakers, was first to colonize this area. Their democratic customs were not in favor of England but worked well in this new land of America. This photograph shows the Friends Meeting House before it was faced with red brick but where it still stands today. It is owned by the Bordentown Historical Society. (Photograph courtesy of Debra Cramer.)

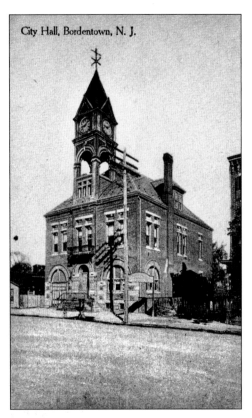

City Hall, Bordentown, N. J.

This is a later city hall building in Bordentown. Located on Crosswicks Street, it contained the police department, including a jail cell, the Delaware Fire Company, a city clerk, and a large council chamber. The 19th-century Seth Thomas clock, which is from the oldest established American clock company, is still working. The clock also honors Bordentonian William F. Allen, who established four United States time zones (1883) at the request of the railroad companies. This enabled our large country to synchronize time schedules so that travelers could then make connections with reliable efficiency. The four time zones are still in use today. (Postcard courtesy of Gerry Young.)

Dr. James Gilbert, mayor from 1913 to 1917, was credited with obtaining the trolley line in Bordentown. The council disagreed with his proposal until they learned that paving Burlington, Farnsworth, and Park Streets were part of the package. A powerhouse, the Bordentown Electric Light & Motor Company, was constructed to supply power to the trolley line. However, the railroad did not like the competition and had men rip out the electric poles during the night. Court action resolved the situation and trolley service came into being. Eventually, service was offered from Camden to Trenton. The cars were finished in white and gold with vermilion gear and natural oak doors. A long-time trolley strike sent people back to the trains and into the new bus line. The trolley tracks were removed in 1932. (Photograph courtesy of Larry Gordon.)

In 1867, an act was passed to create a city government consisting of nine councilmen. The first election, in 1868, found Dr. Leo H. DeLange to be the first mayor of Bordentown. Seen here are, from left to right, Leo H. DeLange, son Louie, wife Mary Ann, and son Alexander Clark DeLange. Alexander Clark became a stage star in the 1920s. (Photograph courtesy of Larry Gordon.)

Joseph R. Malone Sr., shown here with his wife, née Anna Caufield, was born in Bordentown. He ran a coffee and tea business and went on to real estate and insurance. In 1910, he became the city clerk and held that position for 35 years. A busy man, he also was a correspondent for the *Trenton Times*, a volunteer with Humane Fire Company, and director of the Peoples Building and Loan Association. (Photograph courtesy of Joseph R. Malone III.)

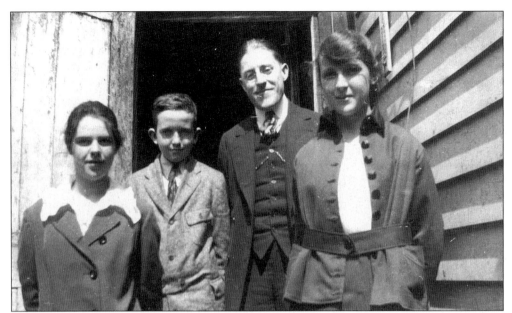

William R. Flynn (third from the left), shown here with some unidentified youth in the 1930s, was honored for his civic devotion to the town. The Hilltop Park was renamed William R. Flynn Memorial Park as a permanent remembrance to him at the dedication on Armistice Day, 1936. (Photograph courtesy of Francis Glancey.)

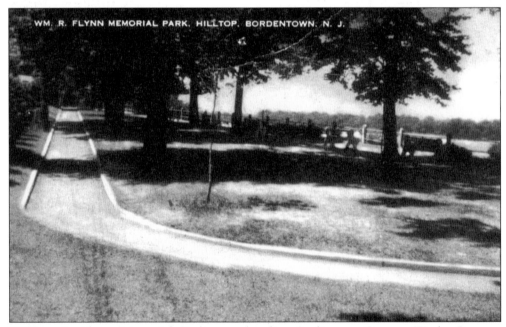

William R. Flynn Memorial Park was the first Burlington County Works Progress Administration project completed. On the dedication day, the largest parade ever produced in Bordentown began on Prince Street and wound through the town ending at the Second Street entrance to the landscaped park. (Photograph courtesy of Francis Glancey.)

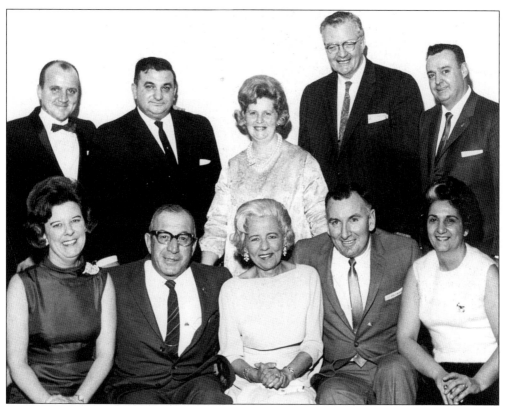

This photograph, taken in 1957, shows some Bordentown members of the Democratic Club. Seen here are, from left to right, the following: (front row) Doris Tyrell, Joseph Mercantini, Anne Mercantini, Claude Appleby, and Jane Diveley; (back row) Anthony P. Tunney, John Costa, Pat Tunney, G. Edward Koenig, and Thomas Diveley. (Photograph courtesy of Peg Ravatt.)

This is Joseph R. Malone III and his father, Joseph R. Malone Jr. Young Joe grew up to devote his time and talents to the city he loves. He was the youngest mayor on record and stayed mayor of Bordentown for 20 years. He brought national attention to the city with his Workfare Program and his teenage curfew. The CBS program *60 Minutes* came for interviews, as did the *New York Times* and other television stations, radio stations, and newspapers across the nation. (Photograph courtesy of Joseph R. Malone III.)

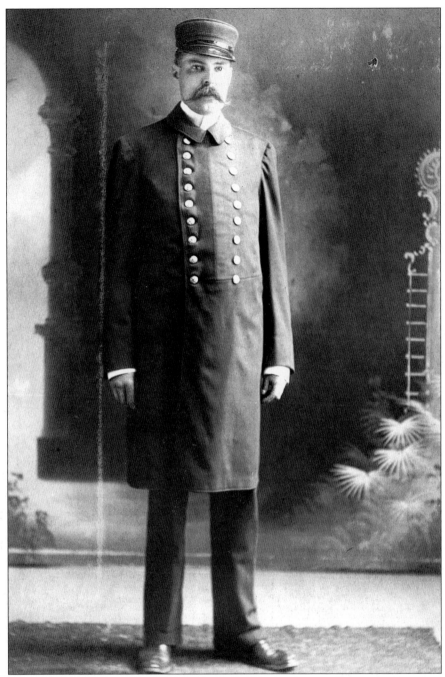

Born and schooled in Bordentown, Amos P. Thorn liked police work even as a youngster. He learned cigar making, became an inspector of the Pennsylvania Railroad, but he really came into his own when the Bordentown Common Council named him police chief in 1904. Here, he is dressed in his policeman uniform, ready for duty. When he was chief of police, he took the beat during the daytime while officers Ryan and Quain patrolled the beat at night. Maurice English was a special officer, substituting for the regular officers when needed. Chief Thorn also was a member of Hope Hose Fire Company. (Photograph courtesy of Marilyn Fraser.)

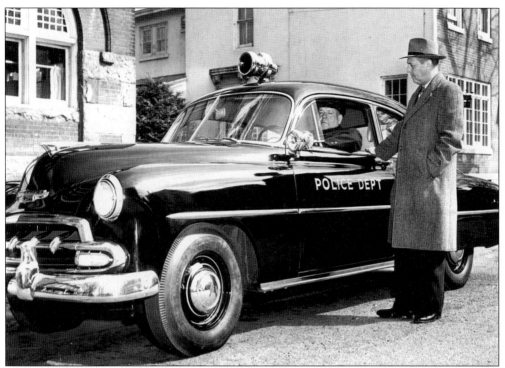

It is 1952 and Mayor Ed Clark is checking out the police car being driven by Bordentown Police Chief Joseph M. Girton in front of city hall on Crosswicks Street. This was a time when cars boasted real chrome, including the siren on the roof. Chief Girton joined he police department in 1940 as a patrolman. (Photograph courtesy of John McCoy.)

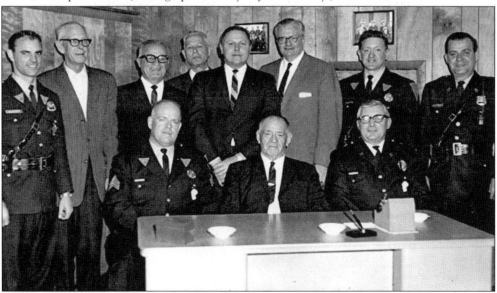

Working together in the 1960s in the still-new police department offices are, from left to right, the following: (front row) J. Girton, Jacob Oswald (mayor of Bordentown Township), and E. Laureti; (back row) J. Cannon, L. Lippencott, G. Valentini, G. Dare, P. Casey, E. Koenig (Bordentown City mayor), J. Allen, and R. Campbell. (Photograph courtesy of Chief Phil Castagna.)

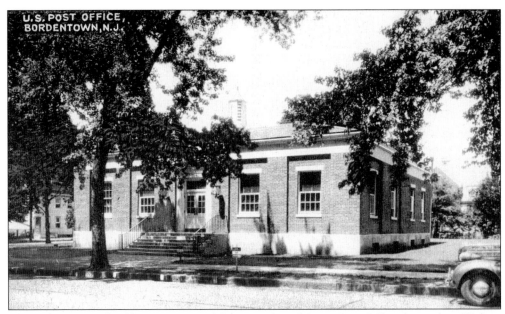

The dedication and public inspection of this new United States Post Office, located on Walnut Street, took place on Saturday, April 29, 1939. A lavish parade was held in honor of the new building being opened. Following the parade, James D. Magee, the postmaster, participated in the ceremony, as did Mayor William C. Warrack and other dignitaries of the area. (Postcard courtesy of Gerry Young.)

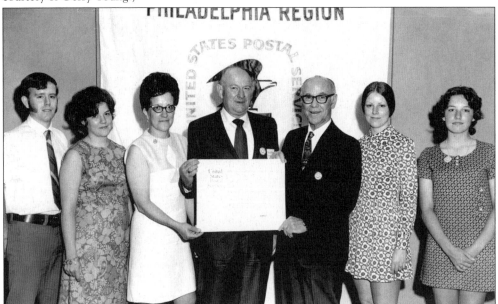

The Mitchell family shares in the honor while Donald B. Mitchell becomes postmaster of Bordentown. Seen here are, from left to right, son Charles, daughter Barbara, wife J. Patricia, Donald B. Mitchell, the area supervisor, daughter Margaret, and daughter Elaine. A post office has been available to Bordentown residents since 1800. A permanent dwelling of brick was erected on the exact site where the first postmaster of Bordentown, William Norcross, lived in 1800. (Photograph courtesy of Barbara Mitchell.)

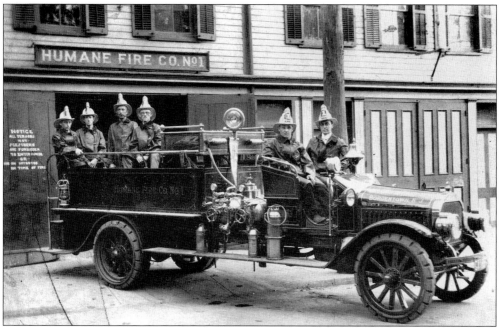

This is a view of the Humane Fire Company No. 1 all spit and polish and ready to do its job. This volunteer fire company came out of a reorganization in 1858 of the Union Fire Company. Its history dates back to 1767. Humane was also first to update their equipment when they purchased a Mack truck in 1916. (Photograph courtesy of Dr. David Addis.)

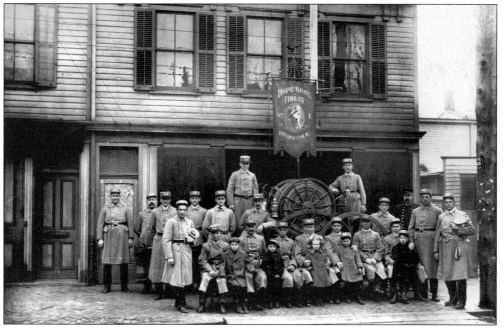

The Hope Hose Fire Company is shown here at the firehouse on West Burlington Street. The company was organized in 1854, and the city purchased this property for them in 1877 for $405. They created a marching band in 1925 and were often winners of trophies in competitions and parades. (Photograph courtesy of Francis Glancey.)

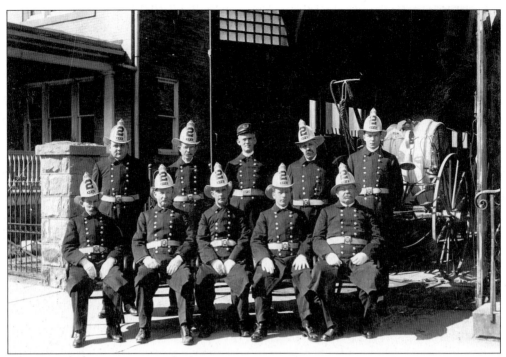

The Delaware Fire Company, shown here in their new home on Crosswicks Street, was formed in 1850. A committee of women purchased a hose carriage with funds they solicited. The house you see on the left is where fireman Charles Herbert (standing in the back row, on the left) lived. The photograph was probably taken c. 1915. (Photograph courtesy of Francis Glancey.)

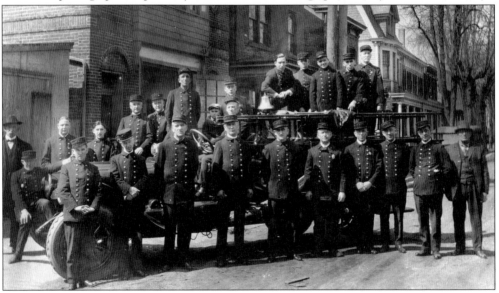

The Weccacoe Hose Company No. 2 was first formed in 1871 and located on Second Street near the Hilltop. The charter officers were David L. Hall, president; Moses Wold, vice-president; John P Hutchinson, secretary; Joseph Allen, treasurer; and Joseph B. Forker, foreman. In 1910, William Rice bought it for $107 and moved it to its present location. (Photograph courtesy of John McCoy.)

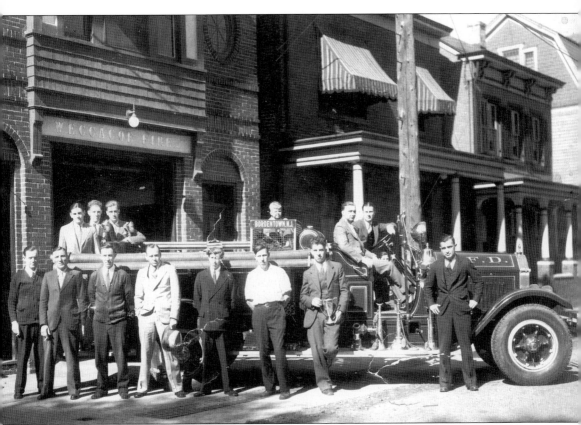

This company's first hose cart, purchased in Camden from the Weccacoe Hose Company, supplied the name for their fire company. Here, the men from the firehouse located on Second Street have the truck all shined and ready to show for the 250th anniversary of Bordentown in 1932. The members of the proud group are, from left to right, as follows: (standing) James Campbell, Jack Lovett, Drake Campbell, Lawrence Newell, Mike Foster, Raymond Foster, Bob Heisler, and Gus Valentini; (on the truck) James Kinsley, James Rodgers, James McShane, Raymond Anderson, John Bell, and James Anderson. The youngster behind the truck is Albert Eleuteri. The firehouse is now a private residence. (Photograph courtesy of John "Bud" Johnson.)

This photograph of the old Victorian railroad station shows the different track connections. The tracks running through the tunnel go under Prince Street. The tracks that curve off to the left go to Trenton. (Photograph courtesy of Janet Cremer Lynch.)

The John Bull Monument, a 30-ton cube of Baltimore granite, 5 feet wide and 7 feet high, first rested about a mile east of town at a location selected by Isaac Dripps, the man who first put the *John Bull* together. The track that circles the monument is the original track, which was laid in 1831. The monument now overlooks a train that still travels through the underpass along Railroad Avenue. (Photograph courtesy of Larry Gordon.)

# Four

# DOWNTOWN

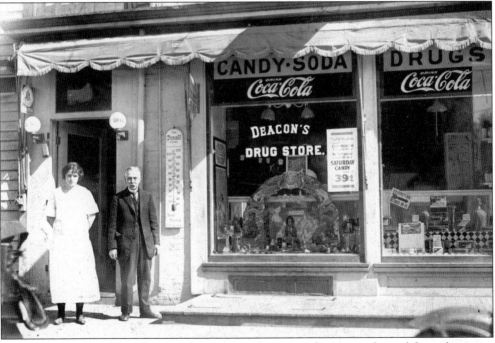

George F. Deacon, shown here in the early 1900s, received some unplanned free advertising when a photograph was taken of his son Franklin posed with his winning prize hog at the Trenton Fair. The newspaper printed incorrectly that George was a pig farmer and sent the article across the entire country. Deacon's Drug Store was a familiar sight on Farnsworth Avenue for many years. Deacon was severely burned after some turpentine exploded at the bottom of his yard behind the store. After that incident, he retired. Deacon had spent 50 years as a pharmacist, and 40 of those years were in his own store. Martin Kilty succeeded him in business. The woman is unidentified. (Photographs courtesy of John Groze.)

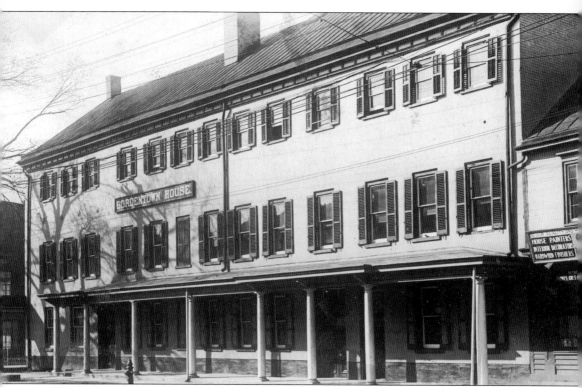

This building was first occupied in 1778 by the Academy for Boys School, run by Burgess Allison. Levi Davis acquired the property in 1832 and opened it as a public house. He named it the Bordentown House. Under Davis's care, it became one of the best-known public houses in the state. By 1913, when this photograph was taken, it was being operated by grandson Howard Davis with his wife Effie. (Photograph courtesy of Francis Glancey.)

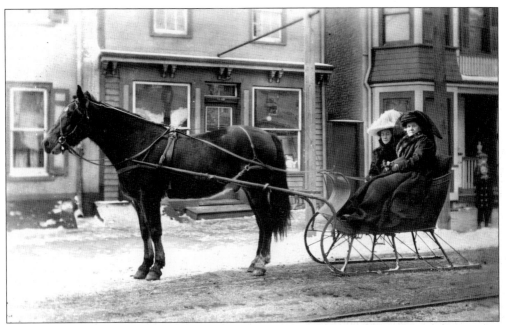

In the winters of the old days there was enough snow to bring out the sleigh. Effie Davis, wearing a white hat, is seen in this *c.* 1912 photograph. She was the owner of the Bordentown House on Farnsworth Avenue. Mrs. David Martin is wearing the black hat. The photograph was taken by James L. Glancey, whose photography shop is seen behind the horse. (Photograph courtesy of Francis Glancey.)

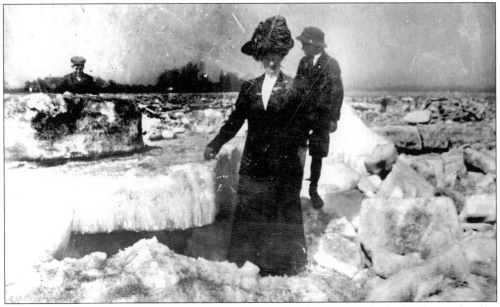

At a time when the Delaware River would freeze over in the winter, Elizabeth Glancey has her photograph taken by her husband, James, to prove it. In the early 1900s, the Delaware River would freeze solid enough for cars to be driven on it. Wintertime sports were always enjoyed by many and were even depicted in local paintings dating back to the late 1700s through the 1800s. (Photograph courtesy of Francis Glancey.)

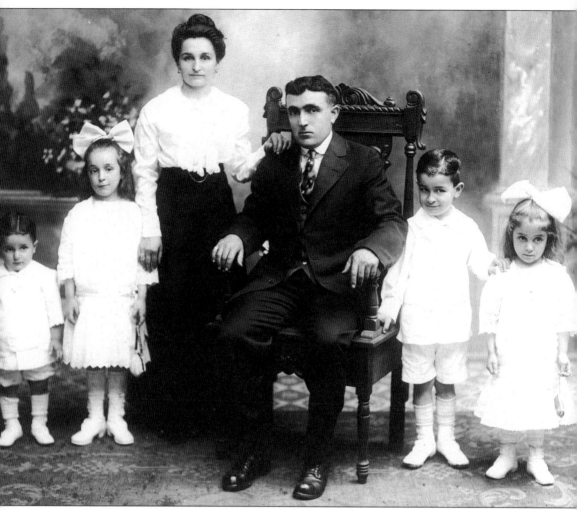

One of the young men who left the farm in Italy to emigrate to Bordentown in 1903 was Innocenzo "Joe" Valentini. He came from Gavelli, Perugia, Italy. Joe is shown here with his family. They are, from left to right, son Mike, daughter Elsie, wife Maria (Martoni), son Gus, and daughter Sola. Joe eventually owned a pool parlor, a shoeshine stand, and a grocery. The concrete blocks he made were ranked second best in the entire state for several years. He carted fruits and vegetables and delivered the first store bread to residents in the area. He also bought many parcels of real estate in Bordentown. Their daughters Elsie, a stenograph and typing teacher at Bordentown High School for many years, and Sola, now retired from Sears Roebuck Company, still reside in the family home. Joe bought the residence at 154 Farnsworth Avenue in 1918. (Photograph courtesy of Elsie and Sola Valentini.)

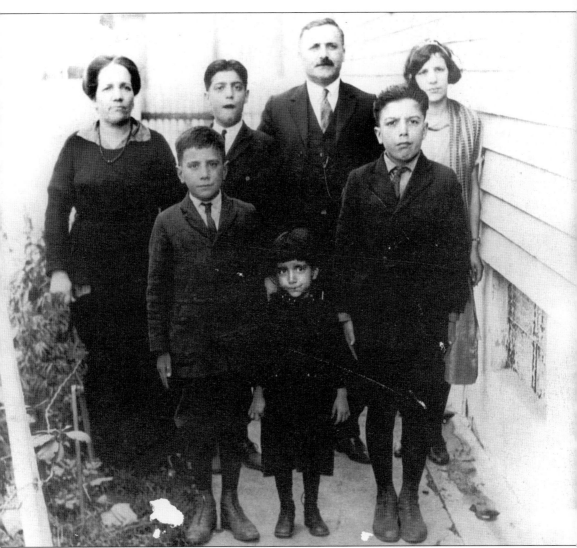

Adam Spundarelli left Italy after he fought in the Italian army during the Ethiopian war of 1895 and immigrated to Trenton. He then found his way to Bordentown as a gardener for Thomas Adams and, later, on the John V. Rice estate. His next step was to open a barbershop in the Bordentown Register building for several years. In 1928, he purchased the building at 148 Farnsworth Avenue and moved his barbershop there. This photograph was taken next to the family's residence at 42 Second Street, where descendants still live today. Seen here are, from left to right, the following: (front row) children George, Tippy, and Gus; (back row) wife Remonilda, son John, Adam, and daughter Mary. Spundarelli's son Gus followed in his father's footsteps and operated the barbershop until the late 1970s. George and Tippy later owned and operated Tippy's Luncheonette on the south-east corner of Farnsworth and Church Streets. (Photograph courtesy of Pat Spundarelli.)

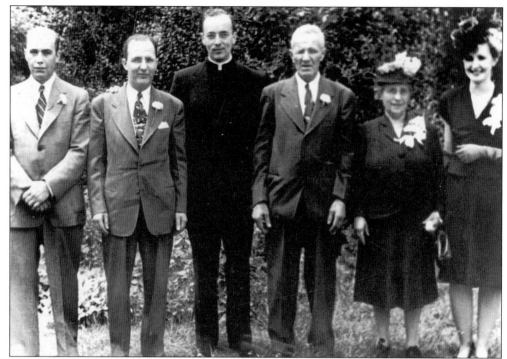

The Capitani family is pictured gathered together for the celebration of ordination into the priesthood of Anthony Capitani. It is May 1946, and proudly lined up, from left to right, are Alex, Lawrence, Anthony, John, Ada, and Inez, the wife of Lawrence. The family owned and operated Cappi's, a grocery store on the corner of Second and Elizabeth Streets. The store was purchased in 1924 by Battista Capitani. (Photograph courtesy of Pat Spundarelli.)

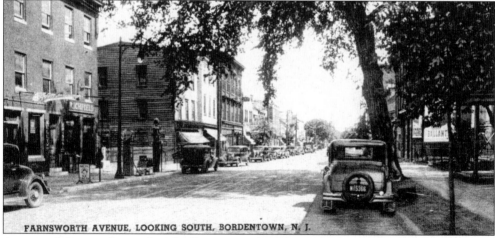

A postcard shows a few unidentified businesses along Farnsworth Avenue in the 1930s. Some of the businesses on the avenue at that time were: Bordentown Register, Mahady's Ice Cream, McDade's Meat Market, Chris's Barber Shop, New Life Lunch, Goldman's Modern Market, Fairlawn Food Stores, App's Hardware, Abbie-Lou Beauty Shoppe, the Town Shop, Eichinger's Bakery, Daley's Hardware, Groveman's Department Store, Greenberg's, Harry's Cut Rate, Min and Bill, Deacon's Drug Store, Kanter's Department Store, and Seidel Brothers. (Postcard courtesy of Gerry Young.)

Pictured here are Serafina and Tony Bankam with their four-year-old daughter, Mary Rose. The Boncampi/Bankams emigrated here from Italy. When Mary Rose grew up she married John Joseph Barrett, who was also of Bordentown. (Photograph courtesy of Merle Barrett.)

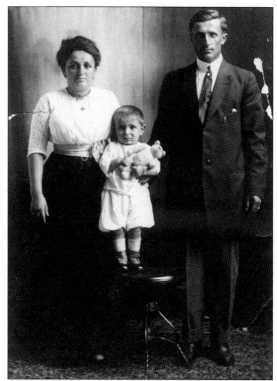

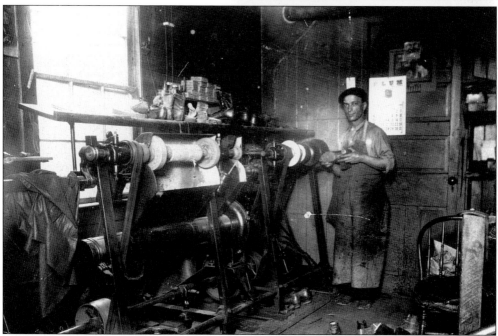

In this photograph, Tony Bankam, whose name was Americanized from Boncampi, is repairing a shoe in his cobbler shop at 202 Farnsworth Avenue in the early 1900s. In later years, his daughter turned the cobbler shop into a retail shoe store. He owned a car in the 1920s, but you had to remove your shoes before he would allow you to enter. (Photograph courtesy of Merle Barrett.)

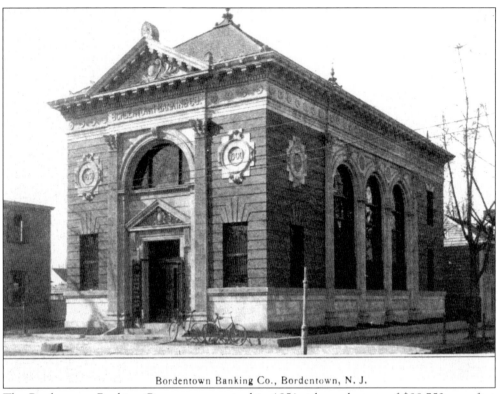

Bordentown Banking Co., Bordentown, N. J.

The Bordentown Banking Company, organized in 1851 with total assets of $98,752, was first located at 29 Farnsworth Avenue. A majority of incorporates were Bordentonians, with the first president of the board of directors being John L. McKnight. In 1901, they opened the new building at the corner of Farnsworth and Walnut Streets. (Postcard courtesy of John McCoy.)

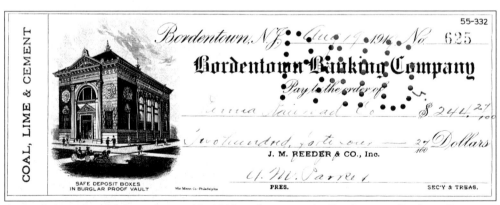

A check from the old days, August 19, 1919, is drawn on the Bordentown Banking Company at its new location. It is payable to the Pennsylvania Railroad Company for $244.27 by J.M. Reeder & Company and signed by the company president, A.M. Parker. Notice that a horse-drawn carriage is pictured rather than a newfangled automobile. Safe deposit boxes in a burglarproof vault are advertised at the bottom of the sketch. (Courtesy of Debra Cramer.)

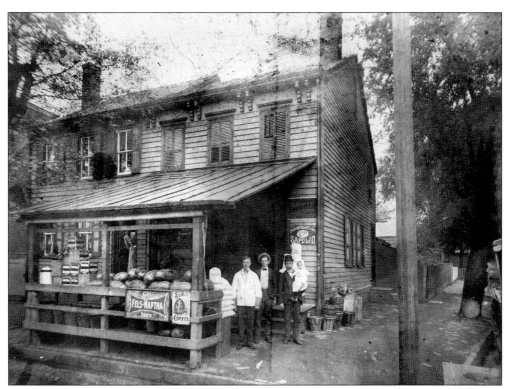

This is an early photograph at the corner of Main Street and East Burlington Street of the J.P. Campbell store before the owner even had time to place a sign up with his name on it. However, the Fels Naptha sign is easy to see. James Flynn, editor of the *Register-News*, suggested changing the name of Main Street to Farnsworth Avenue in 1876. Within six months, the common council voted in the change unanimously. (Photograph courtesy of Barry Hausser.)

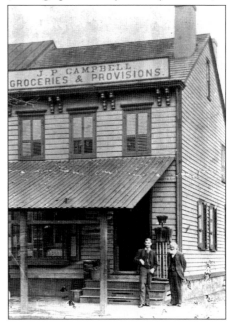

In this *c.* 1878 view of the J.P. Campbell store, its sign is up where all can see it, advertising groceries and provisions. By now, J.P. Campbell was also a justice of the peace. He is on record as having performed marriages. There were several grocery stores in Bordentown at this time. (Photograph courtesy of Barry Hausser.)

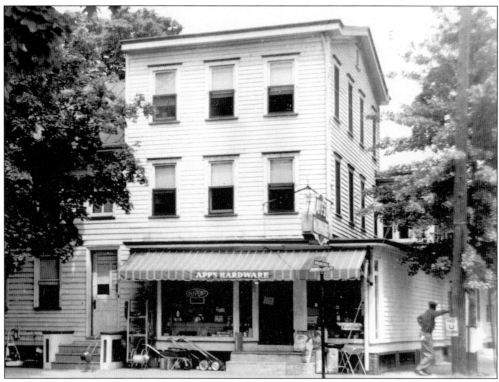

Mel Hausser, the son-in-law of George A. App, has carried on the family business and is in charge of App's Hardware during the time of this photograph, the late 1950s. Many alterations have been made to the building, and the products offered are much more varied. Mel instituted the slogan "Get it at App's." (Photograph courtesy of Barry Hausser.)

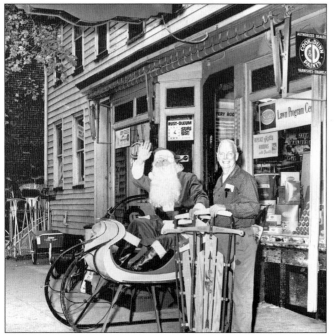

Mel Hausser and Santa Claus stand outside the door at App's Hardware in the late 1950s. It looks like Santa knows where to get what he wants. Again, the store has expanded and includes antiques in its products line. At a later date, Morley Safer interviewed Mel for the show *60 Minutes*. (Photograph courtesy of Barry Hausser.)

In the early 1900s, Chautauqua groups would come to Bordentown to perform lectures, musical programs, magic shows, and other entertainment. They performed at the Mount Moriah Lodge No. 28, Ancient Free and Accepted Masons, on Farnsworth Avenue. A few years later, movies were shown on the second floor of the building. (Photograph courtesy of Larry Gordon.)

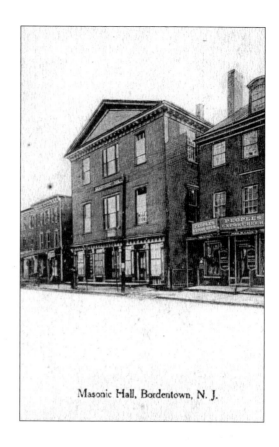

Masonic Hall, Bordentown, N. J.

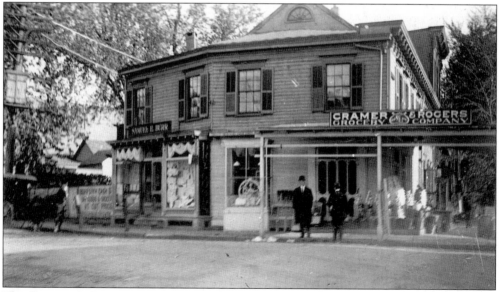

The Cramer & Rogers Grocery Company building was originally known as Burr's Corner. Samuel Burr developed the corner when he came to Bordentown in the mid-1800s. He went on to other endeavors, renting out the front store but keeping the dry goods store open for his wife, Elizabeth, to operate. (Photograph courtesy of Francis Glancey.)

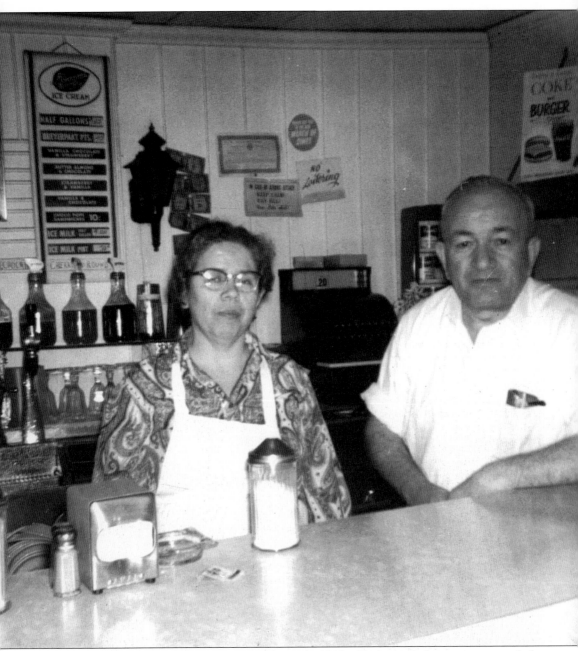

Spiros "Pop" Polios came to America in the early 1900s. He learned the restaurant trade by working at the Bordentown Grill, which was then a very popular diner situated where the two major highways, now Routes 130 and 206, crossed. He returned to Greece and married Vasilo. The couple is shown here in their business, the Town Sweet Shop, better known as "Pop's." The shop was located on Farnsworth Avenue at the corner of West Street. He was especially known for his BLTs, home fries, and the fact that he had a funny story for everyone that came in. Dipping ice cream and cooking for the people of Bordentown delighted them and created wonderful memories for everyone else. Spiros and Vasilo had a son, John, and a daughter, Mary. Mary still lives in town with her husband, Bob. (Photograph courtesy of Mary Gold.)

This photograph shows Feaster's Fine Jewelry on the right before William N. Feaster purchased the building on the left to expand his business and greatly improve the appearance of Bordentown. Feaster originally opened his jewelry store, where he sold Orthphonic Victrolas, at 216 Farnsworth Avenue in 1923. (Photograph courtesy of Diane DiSpaldo.)

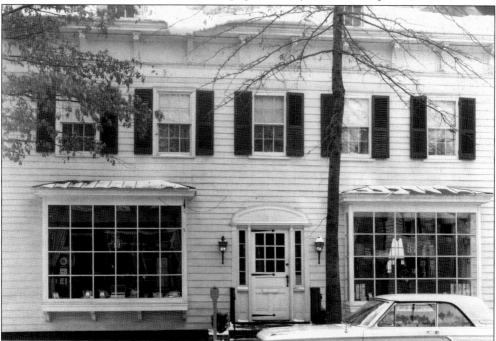

Feaster moved to 308 Farnsworth Avenue, shown here in 1935. He was very active in the Delaware Yachtsmen's League. Feaster's Fine Jewelry is still in business under the ownership of Diane DiSpaldo and Dennis Bator on Farnsworth Avenue in the 100 Block. (Photograph courtesy of Diane Dispaldo.)

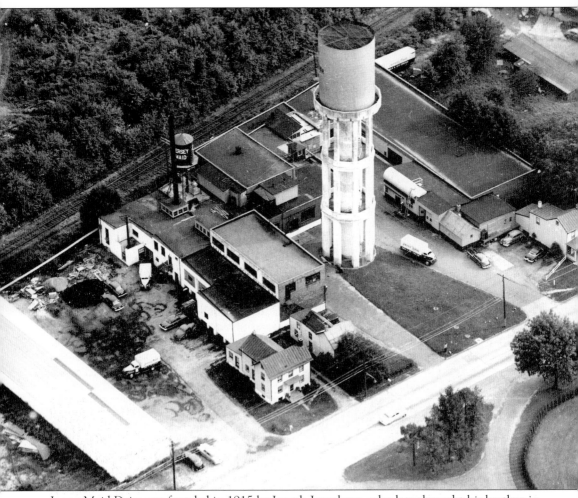

Jersey Maid Dairy was founded in 1915 by Joseph Josephson, who later brought his brother-in-law Max Kessler into the business. The original plant was on Carpenter Street. When the company outgrew that plant it moved to Park Street, shown here. The railroad tracks run along the rear of the property. Across Park Street, the entrance to the former Bonaparte estate, Point Breeze, is visible. Jersey Maid was the first dairy to use paper cartons, homogenized milk, and milk fortified with vitamin D. It was also the first dairy to forego delivery trucks with dry ice and use refrigerated trucks instead. The plant was sold in 1957 to Lehigh Valley Dairies. Both Josephson and Kessler were organizers of the B'nai Abraham Synagogue on Crosswicks Street. (Photograph courtesy of Joseph Horvath.)

In the very early 1900s, the widow of John Van Atta, Elizabeth, bought the property at the corner of Farnsworth Avenue and West Street. She developed a very successful confectionery shop where she sold cigars, candy, soda, and ice cream. Karl Howe Brower, her son-in-law, had the license to sell Breyers Ice Cream in this area. His horse-drawn ice-cream wagon was a familiar sight on the streets of Bordentown. (Photograph courtesy of Jane Fresco.)

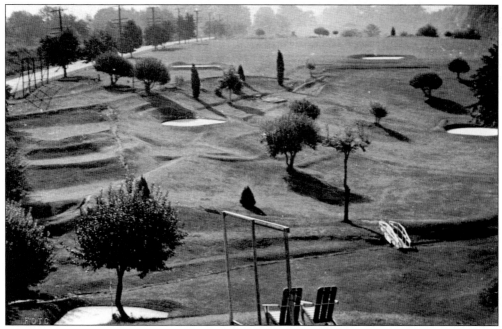

Karl Brower was a man of action. After he built his most welcome ice-cream route in the early part of the century, he went on to create the Laurel Notch Golf Course, located at Route 206 and Georgetown Road. This is one of the views of the golf course, which was also a very successful endeavor. (Photograph courtesy of Jane Fresco.)

This photograph, taken in the late 1920s at Church Brick in Fieldsboro, shows, from left to right, Samuel Church, LeRoy Church Sr., Thomas J. Church (founder), and T. Burtis Church Sr. In 1925, LeRoy donated all the common brick for use in the Bordentown Free Library. In 1940, LeRoy was elected as a life member to the Legion of Honor U.S.A. Flag Association. (Photograph courtesy of Gloria Church Spundarelli.)

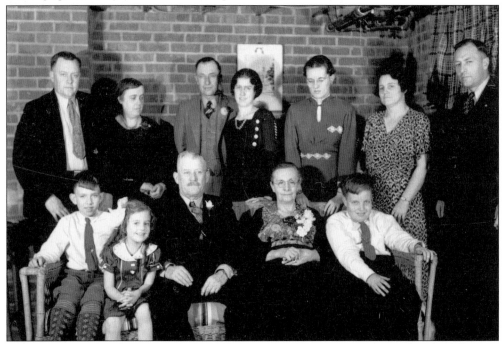

In this photograph, celebrating a 50th wedding anniversary are, from left to right, the following: (front row) Thomas Jr., Gloria, Thomas J. Sr., Catherine, and LeRoy Jr.; (back row) Sam, Milly, T. Burtis, Alice, Grace, Dolly, and Roy Sr. (Photograph courtesy of Gloria Church Spundarelli.)

The Mercantini brothers first came to America from Italy in 1902. It was not long before they opened businesses of their own. John operated a small grocery, and Maurice ran a theater on the second floor of the Masonic Hall. Soon, they built their own movie house, the Bordentonian. By 1923, they bought the property at Farnsworth and Crosswicks Streets, the Washington House. This was the oldest hotel in Bordentown. They renovated it completely and were in the automobile business. The garage held many cars inside, and there was parking for 100 cars behind the building. In 1925, they became Chevrolet dealers. The business eventually moved out to Route 206 in the 1960s. In this photograph, celebrating 25 years in business, are, from the left to right, the following: (front row) Tida Mercantini Stanzione, Teresa Mercantini, John Mercantini, Fena Mercantini Walters, and Helen Mercantini Lynch; (back row ) Neptune Mercantini, Louis "Bucky" Mercantini, Maurice Mercantini, Alphonse Mercantini, and Joseph A. Mercantini Sr. (Photograph courtesy of Joann Mercantini Mahon.)

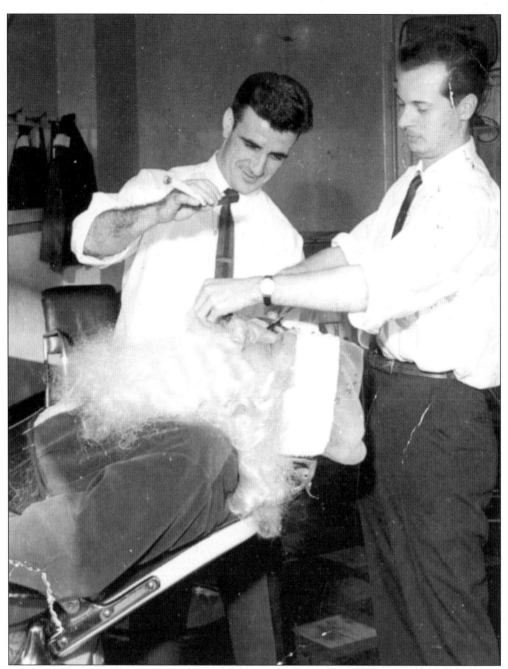

Angelo Falvo came from Soveria de Mannelli, Calabria, Italy, to Bordentown as a teenager. Starting in the 1950s, he had a temporary job as the second barber to Chris Corvo, the owner of the barbershop. He eventually took over the business as Chris retired. Angelo stayed for 43 years at Chris's Barber Shop on Farnsworth Avenue, often serving 4 generations of a single family. His stories were every bit as good as his haircuts; his jokes, spoken with an Italian accent, were even better. The barbershop retained that Victorian flair with the porcelain and leather old-time barber chairs, old walnut furniture, and the precision and care of the old-time barber. (Author's collection.)

## Five

# PAINTERS, POETS, AND PATRIOTS

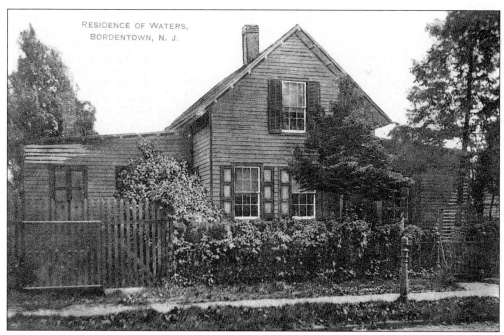

Susan C. Waters (1823–1900) lived with her husband, William C. Waters, in this house, which they built on Mary Street. After exhausting their subjects in this area, they traveled to paint other areas. Longing for home, they returned to Bordentown and rebought their former home. Eventually, Susan's pastoral scenes became the most famous of her paintings, particularly scenes with animals. (Postcard courtesy of Gerry Young.)

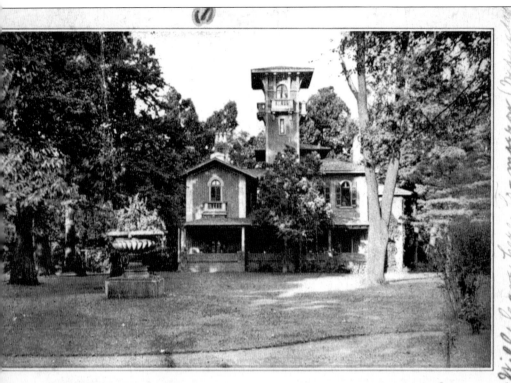

Cromwell residence, formerly residence of Waugh, the artist, Bordentown, N. J.

Samuel Bell Waugh, famed portrait artist of his time, built this home on the hilltop on Bank Street. He studied many years in Europe and had a townhouse in Philadelphia. The Waugh family, talented and remarkable, spent 50 summers here. One daughter was an accomplished pianist, and their daughter Ida was also a portrait painter. Waugh's son Frederick was born in Bordentown and had marine paintings hung in the Metropolitan Museums of Art in New York City and Washington, D.C. Like his father, he also spent many years in Europe. The marine paintings of Frederick are still sought after and sell for high prices. The brother of Samuel Waugh, James, and his niece Amy were also famous artists. (Postcard courtesy of Debra Cramer.)

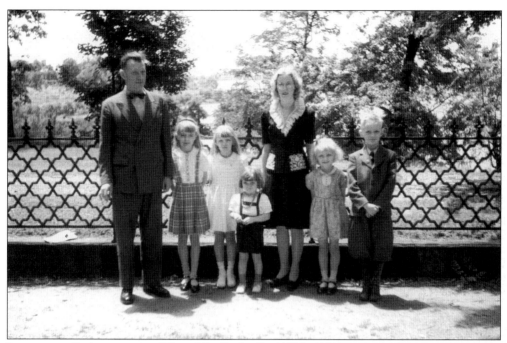

Internationally known artist Edward R. Burke Sr. (1899–1958) is shown here in 1944 at the beginning of Prince Street with his family. They are, from left to right, daughters Betty Ann, Sheila, and Maida; wife Bette; daughter Anita; and son Edward R. Burke Jr. His portrait of Clara Barton was dedicated and presented to the new Clara Barton Elementary School in 1957. (Photograph courtesy of Betty Ann Burke.)

Shown here is a portrait of Logan Fitts, titled *Logan Fitts*, painted by Edward R. Burke Sr. *Across the Water*, a painting of the Delaware and Raritan Canal, was also part of Burke's contributions to the art world. He was also very actively engaged in commercial art and stage settings. The William Emlen Creeson traveling scholarship was awarded to him for study in Paris. (Photograph courtesy of Betty Ann Burke.)

63

Edward R. Burke painted this peaceful scene of a very controversial setting and titled it *Bordentown Monarch*. In 1949, Mayor Lewis M. Parker received a petition signed by 185 residents of Bordentown to retain this beautiful old elm tree at the head of Railroad Avenue at Farnsworth Avenue. An alternate plan for laying a concrete street swerving around the tree was also presented, to no avail. The tree was removed anyway. The building behind the tree was later torn down for urban renewal. It is now the site of Ross Factory Service. The Masonic Temple is the building with the peaked roof and remains as such. The building on the left was once the location of the Bordentown House Hotel. That building was removed to make way for the Acme Food Market, which was later torn down and is presently the location of Boyd's Pharmacy and Liquor Store. (Photograph courtesy of Betty Ann Burke.)

This 1946 painting by Edward R. Burke shows a Coconut Hill view from the bottom of the hill where the railroad tracks lay. The painting shows part of Christ Episcopal Church and part of the houses that were eventually torn down. No one seems to remember how the name of Coconut Hill came to be. (Photograph courtesy of Betty Ann Burke.)

Bordentown artist Edward R. Burke, on the left, is discussing his portrait of Clara Barton with Walbridge B. Fullington, a social studies teacher at Bordentown Military Institute. He painted the portrait for the dedication of the new Clara Barton Elementary School in 1957. The painting still hangs in its honored spot. (Photograph courtesy of Betty Ann Burke.)

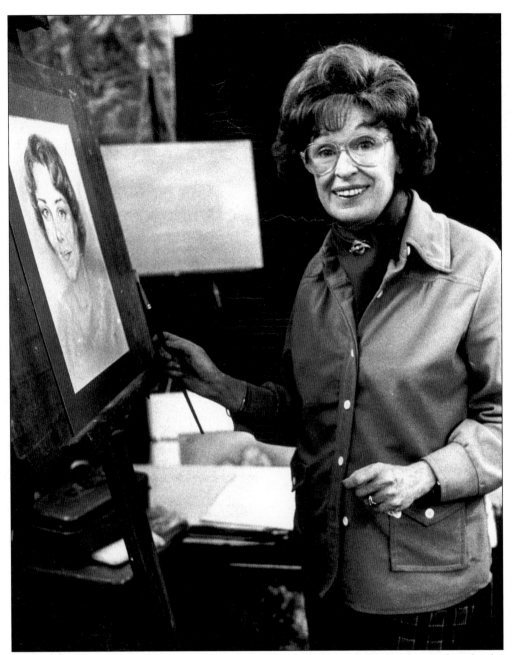

This is a familiar pose for Juanita Crosby, artist and teacher extraordinaire. Juanita bought the 1886 Victorian Citizen Hook and Ladder firehouse building on Walnut Street. She turned it into an art gallery and school on the first floor with an artist residence on the second floor. The Firehouse Gallery has probably had at least one student from most of the families in Bordentown and many from outside of Bordentown. Her student age ranged from 5 years old to 95 years old. Many of her students went on to become art teachers themselves. (Photograph courtesy of Juanita Woodington Crosby.)

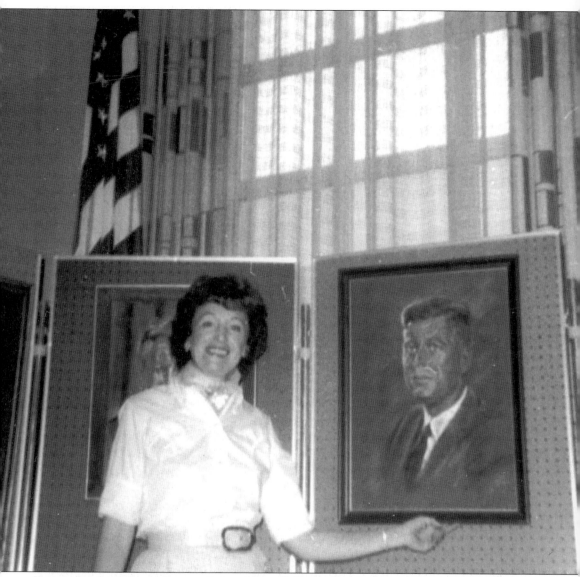

Juanita Crosby indicates her rendition of John F. Kennedy at her two-week, one-man show at the Broad Street Bank in Trenton in 1960. Juanita, which is her signature on all of her paintings, is highly acclaimed for her portraits. She has done portraits of many foreign exchange students, so her paintings hang in houses in England, Sweden, France, and other countries, as well as all the states in this country. In her earlier artist years, she would spend summers down at the shore, sketching people and sometimes their pets on the boardwalk. She drew an entire coloring book for the bicentennial committee showing the history, events, and notable figures of Bordentown. The Bordentown Historical Association is still reprinting the book for use today. (Photograph courtesy of Juanita Woodington Crosby.)

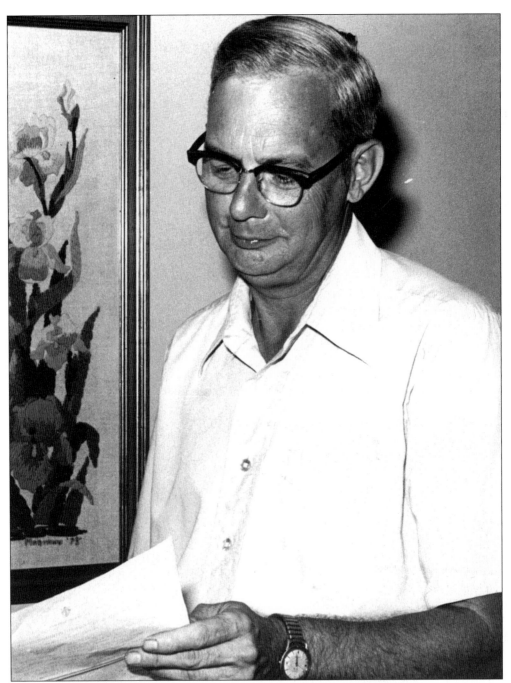

World-renown hybridizer Franklin E. Carr won 28 international awards for the beautiful iris he grew in the small plot of garden behind his house on Mary Street. His flowers still grow in the gardens of the Vatican, Buckingham Palace, Monaco, and the royal gardens in Holland. He was also a master judge for the American Iris Society. Frank created "Point Breeze" in honor of the Bonaparte estate. His creation of the "Pontiff" was noted when he met the Pope. Boehm Porcelain recreated the bloom in a limited and numbered edition. (Photograph courtesy of George Karousatos.)

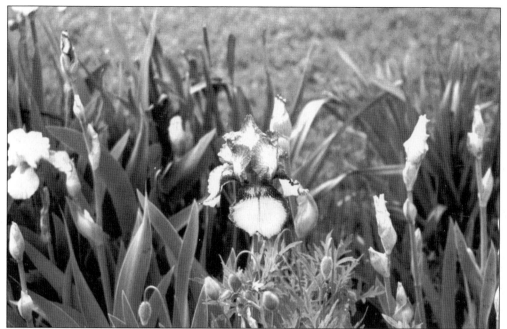

This photograph shows some visions of loveliness from the garden of Franklin E. Carr. At one time, Frank had 300 known species growing fence-to-fence. Everyone was welcome to stop in for a visit, sign his guest book, and have a lesson on growing irises. Neighbors were invited to take rhizomes from the buckets he placed at the curbside. In this sense, his legacy lives on. (Photograph courtesy of David Hoats.)

The Frank Carr irises are planted throughout Bordentown, honoring his creative talent and beautifying the city. These irises are planted in the Christ Episcopal Church graveyard, which is very parklike. Many historians and tourists stroll through the grounds researching the historic names on the tombstones. (Photograph courtesy of David Hoats.)

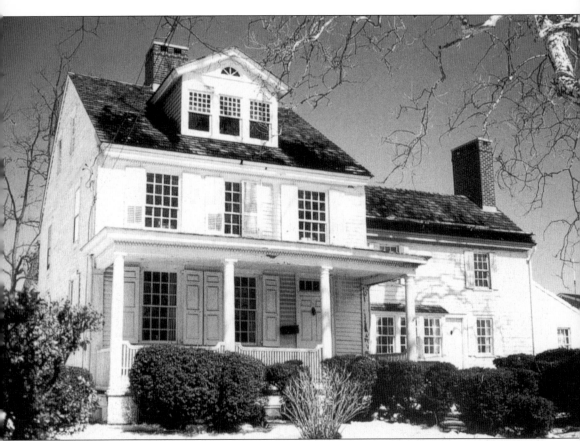

The Gilder House, once owned by Rev. William Gilder, bore a family full of talents. Richard Watson Gilder was an artist as well as a writer. He was editor of *Century Magazine*, a newspaper critic, and considered one of the most influential men in the literary field of the time. Many important people in the literary field sought his acquaintance. He was also a friend of President Cleveland. His sister Jeanette L. Gilder, wrote *Autobiography of a Tomboy*. His brother Joseph was also well known in the literary field. John Francis Gilder was a musician and composer; William was an explorer, writer, and lecturer; and Robert Fulton Gilder was an editor, naturalist, and artist. (Postcard courtesy of David Hoats, photographer.)

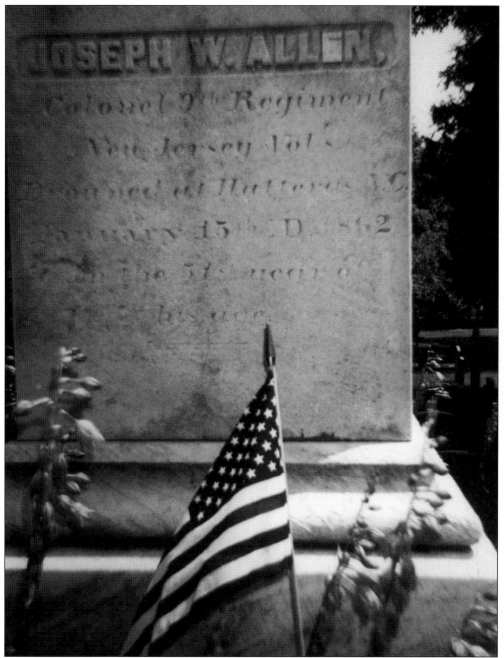

Civil War Col. Joseph W. Allen, 45 of the 9th New Jersey Regiment, is buried at Christ Episcopal Church graveyard, as are many heroes of Bordentown. He drowned off of Hatteras Inlet while attempting to return to his ship the *Ann E. Thompson* when the boat capsized. This was Bordentown's first casualty of the Civil War. Many boys went to war from Bordentown, and many were officers. Maj. Gen. Gersham L. Mott was one of the more noted soldiers, gaining a fine reputation as an officer. He later became a state treasurer. Out of six gun boats built in New Jersey for action in the Civil War, three of them were built in Bordentown. The *Naugatuck* is most well known. It was 101 feet long. (Photograph courtesy of David B. Hoats.)

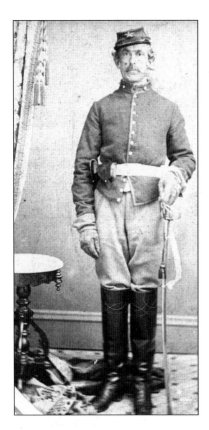

David Kelly Reeder was a blacksmith for the New Jersey Cavalry, Company I, 1st Regiment, starting in August 1861. He became a sergeant. A monument honoring his company stands in Gettysburg National Battlefield. The family lived on Prince Street before and after they served in the Civil War. (Photograph courtesy of Linda Grove Thomas.)

Annie Longshore Reeder, wife of David, was a nurse by profession. Their son was 16 years old when the war broke out, so she went off to war with her husband as a professional nurse. Nurses were greatly needed during the Civil War. Clara Barton was personally requested by President Lincoln to offer her services in gathering supplies for the wounded. (Photograph courtesy of Linda Grove Thomas.)

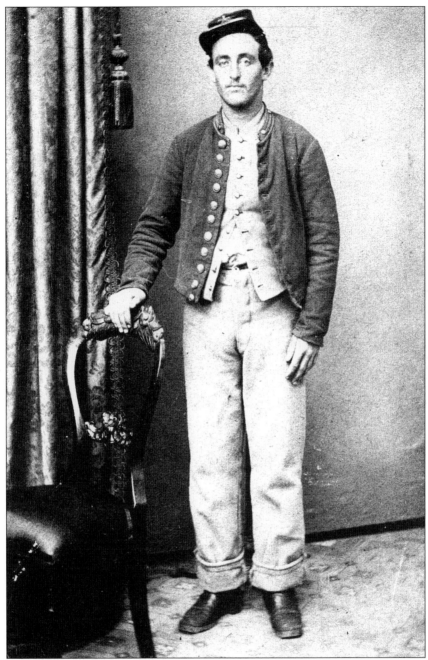

At the age of 16, Francis W. Reeder, son of David and Annie Reeder, joined his mother and father and went off to war too. He became a corporal in the New Jersey Cavalry 18th Regiment, Company I. He was a blacksmith as was his father. When he returned to Bordentown after the war, he married three times. One child came from his first marriage, two children from his second marriage, and with his last wife, Lizzie Davidson, he had nine children. All of the children lived in the Bordentown area as adults. Gladys Reeder Grove, the granddaughter of Francis, is the wife of George Grove and the mother of Gay Cooper and Linda Thomas. (Photograph courtesy of Linda Grove Thomas.)

James Nelson (1843–1904) served with the 10th New Jersey Volunteers, Company C, in the Civil War. He worked for the Camden and Amboy Railroad, and later as a night watchman in Bordentown. In 1900, the family lived on Thompson Street. Volunteer enlistments were for nine months at a time because the North expected the Civil War to be of short duration. The regular pay was $13 a month. New Jersey added $6 for the family or dependents of married men. This photograph was taken c. 1899 at a house that was in the Park Street area. Seen here are, from left to right, the following: (front row) Eliza Nelson, Salina Nelson Newcomb, Jim Lawson, James Nelson, Bill Carter, Mary Anna "Mame" Nelson Carter, and Henry Nelson; (back row) Charles Nelson, Ellen Pittman, Harry Newcomb, Howard Pittman, George Kerr, Howard Nelson, and Andrew Nelson. (Photograph courtesy of Nancy Nelson.)

A proud Bordentown soldier of World War I sent this photograph back to his wife, Becky Nelson, addressed to Park Street at Ward Avenue. The roadways have changed and these two streets have not met in a very long time. (Photograph courtesy of Kevin Nelson.)

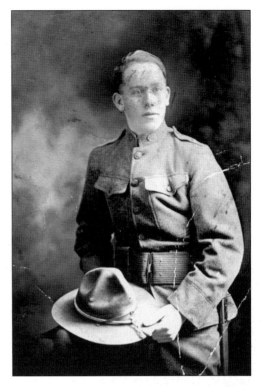

Edward P. Schwoebel is off to World War I after completing training in Aberdeen, Maryland. He was born and lived on Willow Street, married Anna Mae Hamilton, and raised Doris, Evelyn, Robert, and Camilla. The family has traced their genealogy back to Alexander Hamilton. (Photograph courtesy of Evelyn Schwoebel.)

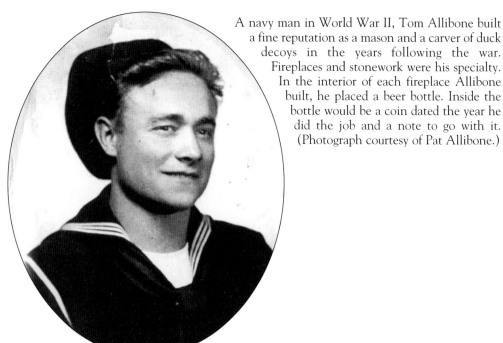

A navy man in World War II, Tom Allibone built a fine reputation as a mason and a carver of duck decoys in the years following the war. Fireplaces and stonework were his specialty. In the interior of each fireplace Allibone built, he placed a beer bottle. Inside the bottle would be a coin dated the year he did the job and a note to go with it. (Photograph courtesy of Pat Allibone.)

John MacDermid, son of Dr. and Mrs. Lynden E. MacDermid, is seen with Ed Friedrich in 1945. Ed came home from World War II with a Bronze Star, a Purple Heart, and a few wounds from the European theatre of operation. He was in the 90th Infantry. John developed an avid interest in military memorabilia. (Photograph courtesy of John MacDermid.)

# Six
# TOWN PEOPLE

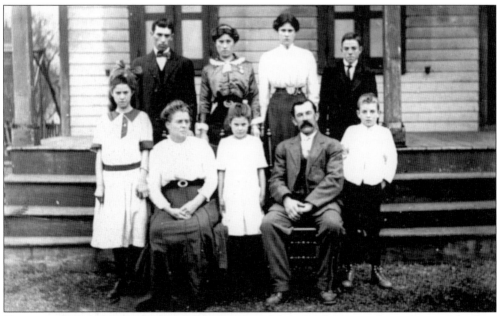

George and Marie Paul with three of their sons and four daughters are shown here on the farm that eventually became Bordentown Regional High School c. 1910. Daughter Catherine Paul became the wife of Thomas J. Church, founder of Church Brick Company in Bordentown. (Photograph courtesy of Gloria Spundarelli.)

Seen here is a young Mary Ellen Nash (Burke), born in Bordentown in 1870. This *c.* 1883 photograph shows the style of the day. Notice the long flowing hair that hangs below her waistline. (Photograph courtesy of Betty Ann Burke.)

This *c.*1900 view of a house on Prince Street shows a man, probably Arthur Sprouls, on the ladder and his wife talking on the front porch with an unidentified person. Their daughter Mildred became the first woman mail carrier in 1945. She married Edward Sholl. They both lived on Prince Street as youngsters. The Borgstroms moved into the house in 1967. (Photograph courtesy of Robert and Claudia Borgstrom.)

Gathered together are four generations in 1908 at the 50th wedding anniversary of the Reaps. Pictured here are, from left to right, the following: (front row) Mary Bennett Reap, Edith Gertrude Carty, and John Reap; (back row) Mary Bennett Reap Carty and John Howard Carty. Four generations of the same family lived at the 3 Spring Street address. (Photograph courtesy of Christiana Carty.)

This photograph, dated 1916, shows the two daughters of Howard and Euphemia "Effie" Davis. The sitting took place in the James L. Glancey Photography Studio located next to the Bordentown House Hotel. The attire of the two young girls depicts the style of the day and the prominence of their parents. Howard and Euphemia were both well-known and respected in town and in the hotel business. (Photograph by James L. Glancey, courtesy of Francis Glancey.)

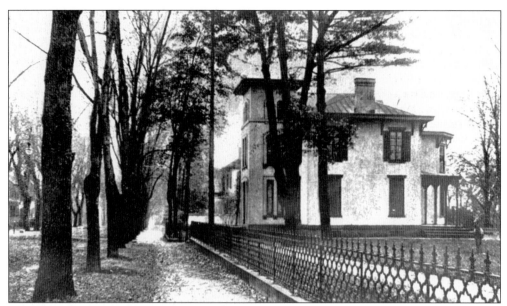

The mansion shown here belonged to George W. Swift Jr., an inventor, in the early 1900s. He came to Bordentown in 1901. Swift held in excess of 100 other American patents, plus Canadian and European patents. The Swift Mansion Machine Shops employed many Bordentonians. In 1919, he purchased four acres of land between East Union Street and Chestnut Street and built 120 brick apartments. His mansion had the first elevator installed in the area. (Photograph courtesy of Larry Gordon.)

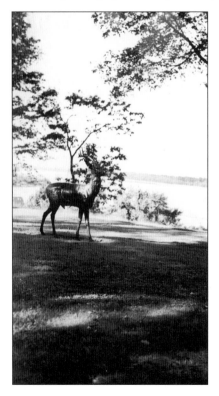

This cast bronze statue of a stag catches the eye of everyone who passes by the Swift Mansion on Prince Street. Placed in the early 1900s, when this was the George W. Swift Jr. property, the stag still overlooks the Delaware River. Swift was very civic minded. He donated $10,000 to the library association toward the erection of a building on the corner of Prince Street and Railroad Avenue. (Photograph courtesy of Kevin Nelson.)

In this 1913 photograph are Ruth Thorn (left) at six years old and her stepsister, Juanita Caldwell, at thirteen years old. Ruth married Charles Nelson, and Juanita married Wallace "Dick" Woodington. Their marriages began the connection of the Nelsons and the Woodingtons. So typical of this period are their lovely Victorian dresses and ribbons in their hair. (Photograph courtesy of Juanita Crosby.)

This is an undated family photograph of a grown-up and married Ruth Thorn Nelson with her children. Seen here are, from left to right, the following: (front row) Vernon and Barbara Nelson; (back row) Ruth, baby David, and Charles "Chippy" Nelson. (Photograph courtesy of Kevin Nelson.)

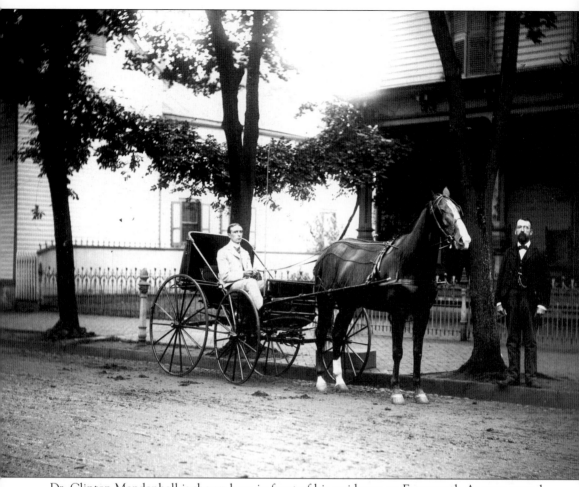

Dr. Clinton Mendenhall is shown here in front of his residence on Farnsworth Avenue seated behind one of his many fine horses. He was a popular doctor with a very successful general practice, including being the city physician. He had a fine reputation also for being a racehorse enthusiast. His horse farm was located on Burlington Street, but a training and racetrack was located out beyond Route 206, off of Georgetown Road. The large front porch is gone from the house, but the wrought iron fence still remains today. Mendenhall was married to Helen Ford. They had one daughter, Marion. The gentleman at the curbside is unidentified. (Photograph courtesy of Richard Conti.)

Dr. Lynden E. MacDermid, affectionately called Dr. "Mac" for the 50 years his practice, which was located on Farnsworth Avenue, is seen here with his wife, Margaret Ann Davis MacDermid. Dr. Mac came to Bordentown from Ottawa, Canada. He was also the physician for the Bordentown Military Institute and the public schools. When he was honored with a testimonial dinner in 1964, 500 people attended. (Photograph courtesy of John MacDermid.)

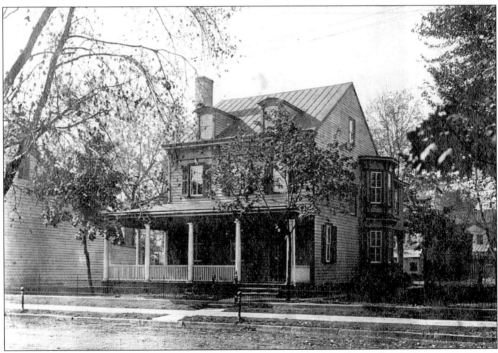

This house at 506 Farnsworth Avenue is pictured as it looked in the early 1900s, in its original form. Dr. "Mac" added a room along the front at the right with an entrance for his patients. The house is now occupied by Joseph R. Malone III, an assemblyman, his wife, Valerie, and their sons. (Photograph courtesy of Joseph R. Malone III.)

The Haines's donkey is the star here. Seen in this 1922 photograph are, from left to right, Peg and Marion Ryan, Clare Glancey, a Haines boy (in Clare's arms), Catharine Haines, Mary Cunningham, and an unidentified person. The donkey would roam freely on unpaved Mary Street, where the Glanceys lived across the street from the Haines family. Elizabeth Glancey would place her freshly baked pies on the window sill to cool until one afternoon, when the Haines's donkey came across the street and ate them. No doubt the aroma was just too much for him to resist. Catherine Haines was the mother of Alfred, Joe, Horace, John (later Judge Haines, who fined Arthur Godfrey, of television, for speeding), Eddie, and Annie. (Photograph by James L. Glancey, courtesy of Francis Glancey.)

Another Haines photograph was taken several years later. Shown here are brother and sister Horace and Annie Haines, children of Catherine Haines (of the donkey fame) on Mary Street. Annie married George Lynch and is the grandmother of Jim Lynch, city commissioner. (Photograph by James L. Glancey, courtesy of Francis Glancey.)

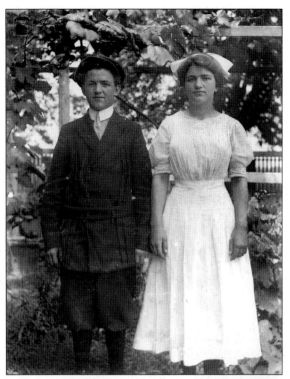

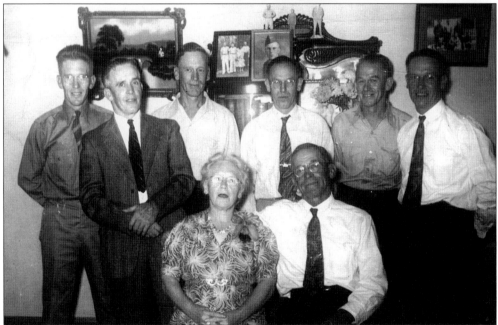

Years later, Charles Nelson, now a Charles Sr., is shown with his family. Seen here are, from left to right, as follows: (front row) Becky and Charles Sr.; (back row) Bob, Charlie (Chippy), Ray, Jack, Andy, and Ernie. All of the Nelsons played a musical instrument, usually more than one, and participated in the area minstrels. Chippy is Kevin Nelson's grandfather. (Photograph courtesy of Kevin Nelson.)

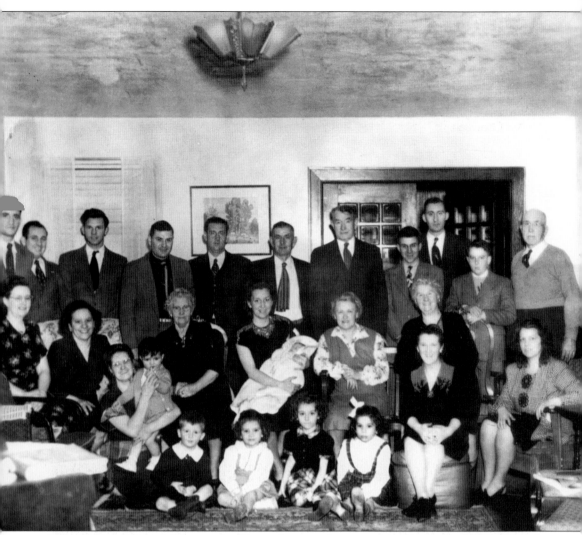

The McDonaugh and Glancey families gather together to celebrate the St. Mary's Church christening of Kevin, shown here being held by his mom, Clare Glancey Strong, in 1948. On her left is Elizabeth Glancey, and on her right is Agnes McDonaugh, who just happen to be sisters. The other young children, from left to right, are Hank Guire, Jim McDonaugh, Ann Louise McDonaugh, Jackie McDonaugh Reed, and Mary Jane McDonaugh Rooney. Many of the Glanceys and McDonaughs came to Bordentown from Scotland and Ireland in the late 1800s and early 1900s. (Photograph courtesy of Jackie Reed.)

Lined up for a photograph session are children of some faculty members at the New Jersey Manual Training and Industrial School. Pictured here are, from left to right, the following: (front row) Bettye Roberts, Lucille Jacobs, and Ann Roberts; (back row) Portia Watson, James Jacobs, and Jeanne Watson. (Photograph courtesy of Bettye Roberts Campbell.)

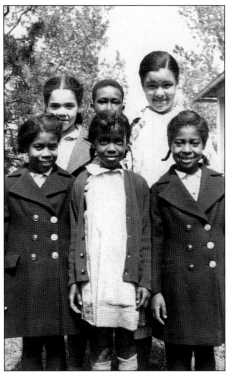

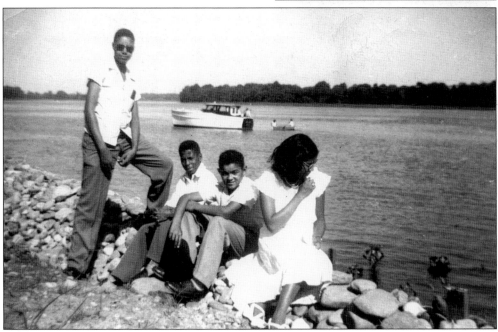

Relaxing at the Delaware riverside are, from left to right, Skip Spurlock, the son of Commandant Emmitt Spurlock; Leander J. Roberts Jr., son of L.J. Roberts Sr. (print shop teacher); William "Butch" R. Valentine III, grandson of Principal W.R. Valentine; and Bettye Roberts, daughter of L.J. Roberts. All are from the Manual Training and Industrial School, which borders the river. (Photograph courtesy of Bettye Roberts Campbell.)

The Manual Training and Industrial School also conducted social gatherings. Here is a brand new Mr. and Mrs. Charles W. Campbell. In 1951, Bettye Roberts married Charles W. Campbell on campus in Valentine Hall. Helen Roberts made the bridal gown for her daughter, Bettye. (Photograph courtesy of Bettye Roberts Campbell.)

To follow in her sister's tradition, Ann Roberts married Andrew Howard in the chapel on campus at the Manual Training and Industrial School in 1953. Also, to further the tradition, she chose to wear the dress her mother made with a small addition of a ruffle along the bottom. (Photograph courtesy of Bettye Roberts Campbell.)

# Seven

# CELEBRATIONS
# AND EVENTS

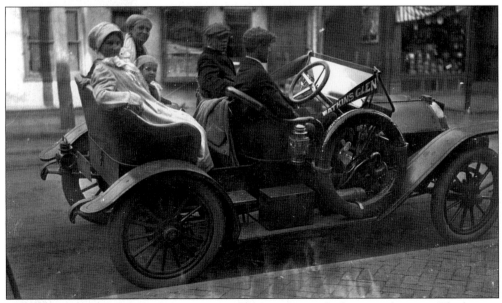

In this undated photograph, the occupants of the car seem to be having a fun time. The banner flying says "Watkins Glen." It could be from one of the parades celebrating the 250th anniversary of Bordentown in 1932. Bordentown took their anniversary celebrations seriously, and everyone joined in. (Photograph by James L. Glancey, courtesy of Francis Glancey.)

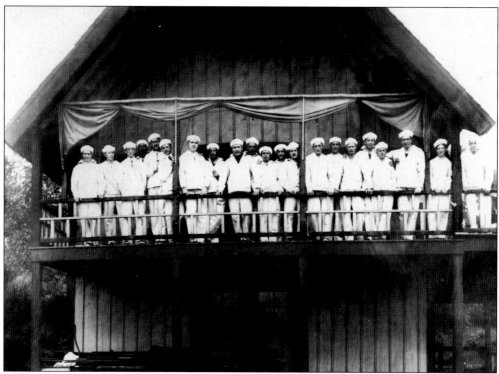

Here at Yapewi Yacht Club, the members come out on the balcony to check on the sun before they head for the water. They maintained a membership in the Delaware River Yacht League. The unique design of the building draws attention to it. The photograph is from *c.* 1920. (Photograph by James L. Glancey, courtesy of Francis Glancey.)

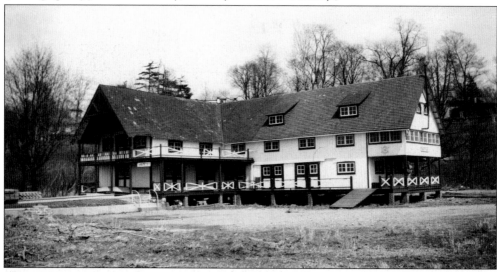

The Yapewi Aquatic Club, a name the Delaware Indians gave to the land it sits on, was chartered in1892. R.C. Woodward, Louis W.H. Wiese, and Horace G. Reeder were among the 33 founders who gathered together and purchased the property from the Ford Machine Works. The works had operated a boat-repair business on the location. They enlarged the building and added a wing, rooms, lockers, and a concrete bulkhead. (Photograph courtesy of John McCoy.)

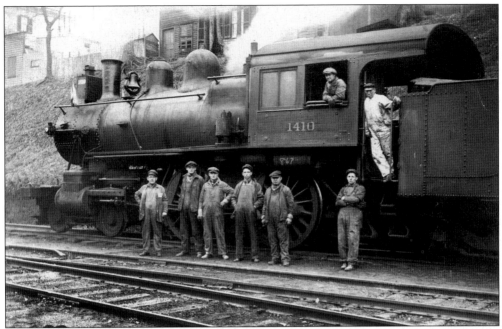

Bordentown has always loved railroads, especially steam engines, and has many collectors of memorabilia today. Here is an undated photograph from the steam-engine days, taken at the bottom of Coconut Hill. The members of the crew are unidentified but enjoyed lining up to have their photograph taken. (Photograph courtesy of John McCoy.)

Many residents earned their living on the railroad, and there was always someone wanting to talk to an engineer and have his picture taken. Of course, there was always someone near to take the picture, too. (Photograph courtesy of Kevin Nelson.)

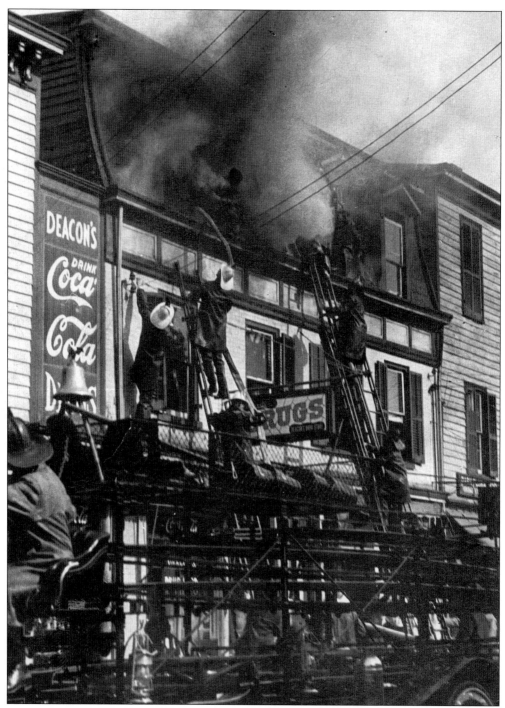

In 1924, a movie about Bordentown was filmed starring Louise Landon and Peggy Rahilly. A staged fire at Deacon's Drug Store was one of the scenes filmed. Fortunately, on hand was one of our excellent fire companies. The Citizen Hook and Ladder Company came to the rescue and seems to have saved the day. The bell on this Boyer fire truck is still in use on the ladder truck at Consolidated Fire Company. (Photograph courtesy of Dr. David Addis.)

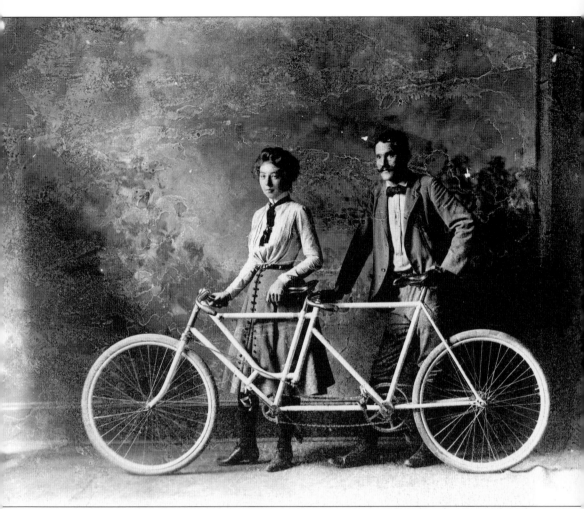

This is a photograph of two unidentified bikers taken in the studio of Mr. James L. Glancey. There is a good chance they belonged to the Owls Bicycle Club. This group formed c. 1900 and featured a 100-mile bicycle ride. The group later switched to automobiles and changed the ride to an automobile rally. Glancey came here in 1907 from Scotland to work as a bricklayer. In 1912, he and his wife, Elizabeth, opened the photography studio devoted to the sale of cameras, plates, films, paper, frames, and amateur photograph supplies. They both were experienced photographers and they built a reputation for first-class portraits and for artistic touches to their subjects. Glancey used his camera to document events and changes in the surrounding area. (Photograph by James L. Glancey, courtesy of Francis Glancey.)

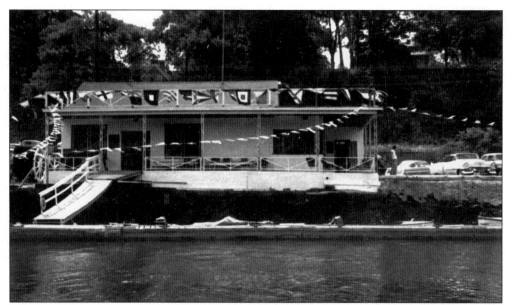

The Bordentown Yacht Club, located at the foot of Farnsworth Avenue where Hilltop Park overlooks it, is shown here all dressed up for a Fourth of July celebration in 1954. The club was formed in 1937 and hosted its first regatta in 1941. The clubhouse has grown and floats have increased since the beginning. (Photograph courtesy of Timothy Morton.)

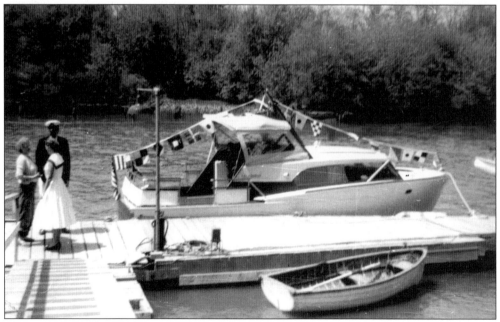

The first commodore of the newly formed Bordentown Yacht Club was William N. Feaster Sr., shown here with his wife, Helen (right), in 1958. Feaster was the prime motivator in encouraging the state's department of conservation to dredge the mouth of Crosswicks Creek to deepen waters. (Photograph courtesy of Timothy Morton.)

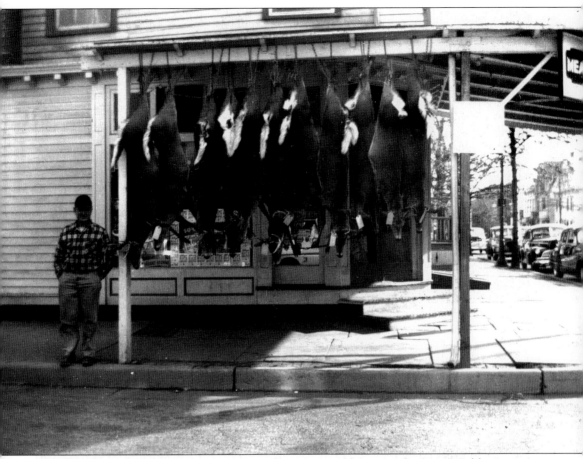

This familiar spot, at the corner of Farnsworth Avenue and Crosswicks Street and known as Burr's Corner since the mid-1800s, is Wright's Market. Joseph Platt proudly displays the result of hunting season with the Bordentown Deer Club in 1947. The deer club hung their game on this corner for many years. The same spot today is the lovely garden of Betty Ann and Paul Castonquay of Betty Ann's Beauty Salon. (Photograph courtesy of J.C. Platt.)

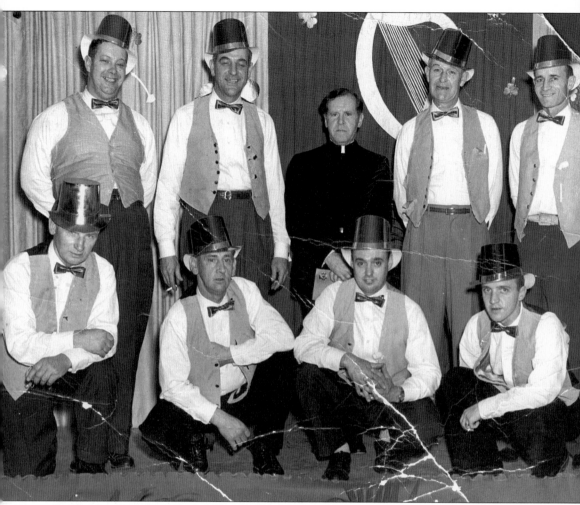

Bordentown has always been great at celebrating St. Patrick's Day, whether you are Irish or not. In this c. 1955 photograph are, from left to right, the following: (front row) Pat Callahan, Jim McDonaugh, Tom Dively, and Tony Tunney; (back row) Murphy, Joe Walton, Father McGrath, Jim Flynn, and Pat Kwelty. The celebration was held at St. Mary's Church hall. (Photograph courtesy of Peg Ravatt.)

*Bordentown, New Jersey*

*Brothers of the Brush*

### Celebrating the 275th Birthday of Bordentown

This is to certify that I, *Claude Appleby*
being a good civic-minded citizen or resident of
Bordentown, do hereby agree to do my civic duty
and grow a mustache, full beard, goat-tee, or side-
burns as a part of the Bordentown Anniversary
Celebration to be held from September 7th to
September 14th, this year, 1957, A. D.

*1682*

*1957*

Guire Printing Co.          13    Bordentown, N. J

The 275th birthday celebration of Bordentown lasted all week. But preparation began long before that. One of the fun events celebrating yesteryear was the "Brother of the Brush." Certificates were doled out and guys took their beards, sideburns, and mustaches very seriously this year. Some of the men just wanted to see how long their beards would grow. (Courtesy of Evelyn Appleby.)

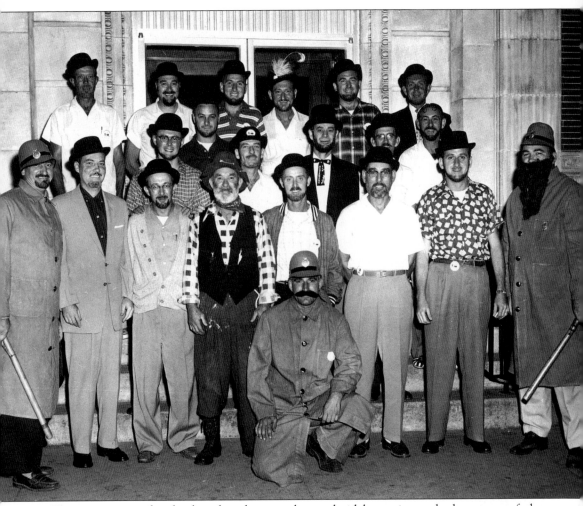

The competition for the best beard, mustache, and sideburns is tough, but some of the participants gladly gathered to validate the event for future generations. Lined up for the photograph are, from left to right, the following: (first row) Merc Mercantini; (second row) unidentified, Jack Terrill, unidentified, Toby Houseworth, Reds Ellis, unidentified, Charlie Eclaran, and Jimmy Lynch; (third row) unidentified, Bill Paul, Shudle, George Oros, Joe Malone Sr., and Jack Hankins; (fourth row) two unidentified, Claude Appleby, Reds Fuller, Joe Kelly, and Joe Tague. (Photograph courtesy of Evelyn Appleby.)

Everyone is enjoying the 275th celebration as it continues with Toby Houseworth as Gabby Hayes and Rose Albertson as his sidekick in this photograph. The year is 1957. (Photograph courtesy of Debbie Allibone DeVuono.)

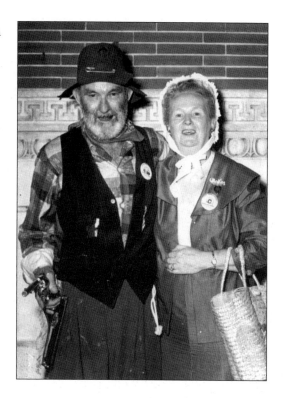

Toby Houseworth seemed to get into a number of the photographs taken during the celebration. Here, he is shown with Jimmy Parcels, who looks like he wished he had a beard. He also looks like he could be a junior policeman for the week. Are those bars of a jail behind them? (Photograph courtesy of Debbie Allibone De Vuono.)

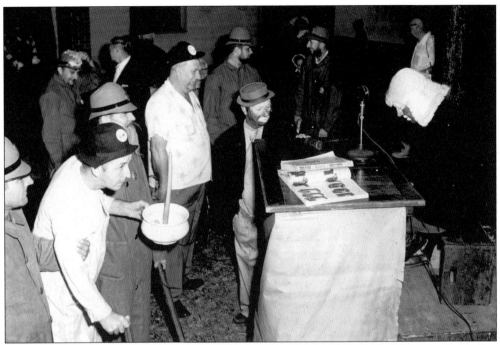

The celebration continues when "Judge" Ed Scholl, of railroad fame, holds court during his kangaroo court session. Pictured here is a noisy situation where everyone is trying to bribe the judge so he can be the winner. No way! You cannot bribe a railroad man! (Photograph courtesy of Debbie Allibone DeVuono.)

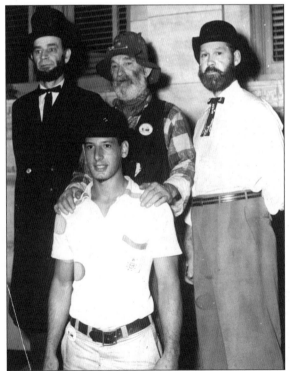

The winners of the "Brothers of the Brush" contest are shown here during the giant town celebration of the 275th anniversary in 1957. Pictured, from left to right, are George Oros, Toby Houseworth, and Albert Thorn. They all look like natural winners. In front is young Albert Thorn. (Photograph courtesy of Debbie Allibone DeVuono.)

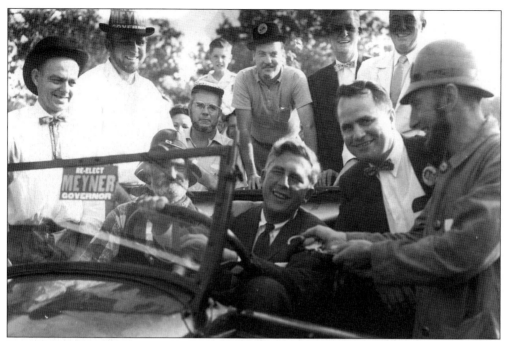

Even the governor of the time, Governor Meyner, stopped into Bordentown to see what all the fuss was about. Without a beard of his own, he was greeted by a very happy group, many with beards. He must have been speeding, though, because that Keystone Cop is about to handcuff him. (Photograph courtesy of Evelyn Appleby.)

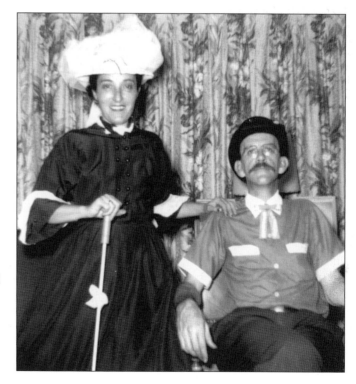

During the 275th anniversary celebration, Joseph R. Malone Jr. and his wife, née Adeline Moretti, join in the festivities, dressing in period attire for the occasion. Bordentown people take their history seriously and sometimes with fun. (Photograph courtesy of Joseph R. Malone III.)

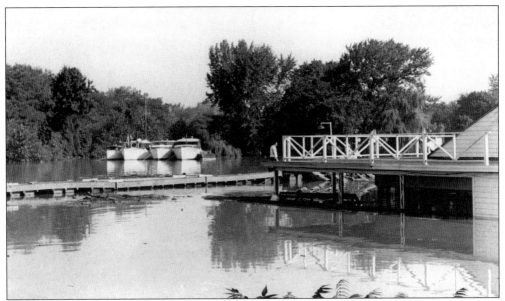

The hurricane of 1955 flooded many of the low areas in and around Bordentown. Here, the Bordentown Yacht Club, organized in 1938, is submerged in water with the floating dock nearly equal to the roof. In 1940, the yacht club won a prize for entering the greatest number of boats in the annual regatta held by the Trenton Yacht Club. (Photograph courtesy of Bill Hensley, photographer.)

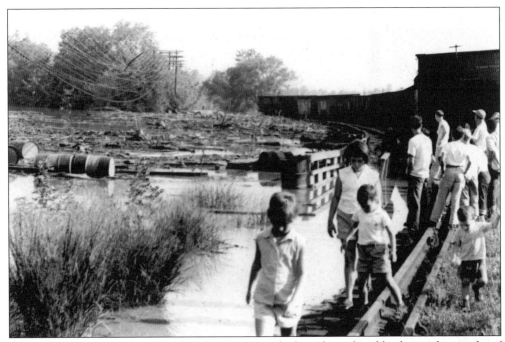

During the hurricane of 1955, railroad cars were parked on the railroad bridge so the weight of them would hold the bridge intact. The town people were out checking the damage the day after the big storm. The bridge runs to the right of the Bordentown Yacht Club over the Crosswicks Creek. (Photograph courtesy of Bill Hensley, photographer.)

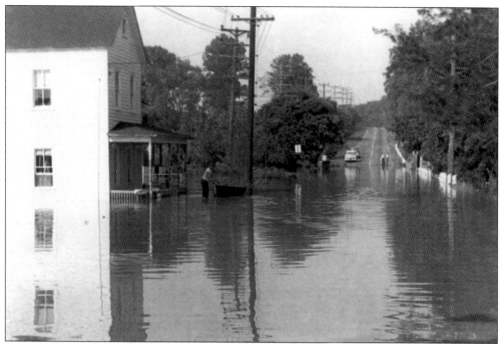

Several people were devastated by the hurricane of 1955. This photograph shows the house on West Burlington Street partially under water as Black's Creek overflowed. Note that this photograph was taken prior to the construction of the interstate overpass over the road to Fieldsboro. (Photograph courtesy of Bill Hensley, photographer.)

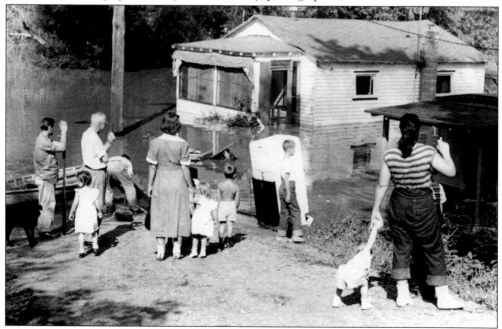

After the storm was over, people came out to see how they could help their neighbors, even if it was only giving sympathy. Black's Creek flooded several houses near its banks. It looks like the refrigerator was saved for another day. (Photograph courtesy of Bill Hensley, photographer.)

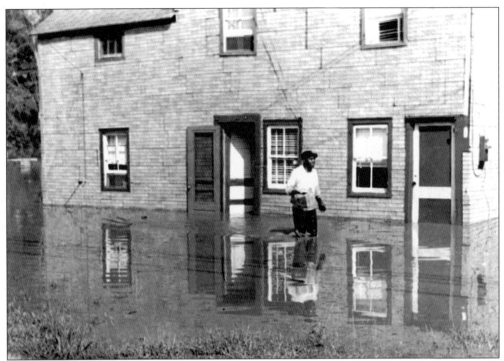

More damage is seen from the overflow of Black's Creek. The man appears to be going to work with his lunch in his hand. However, I am sure he is saving a personal possession from being washed away forever. (Photograph courtesy of Bill Hensley, photographer.)

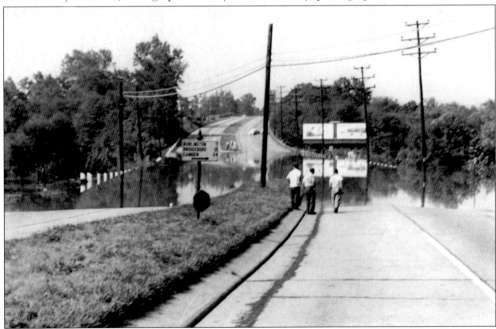

West Burlington Street joins Route 130 underwater in the aftermath of the hurricane. The billboard is reflected in the floodwater, and the sign tells you how many miles to Burlington City, Bridgeboro, and Camden. (Photograph courtesy of Bill Hensley, photographer.)

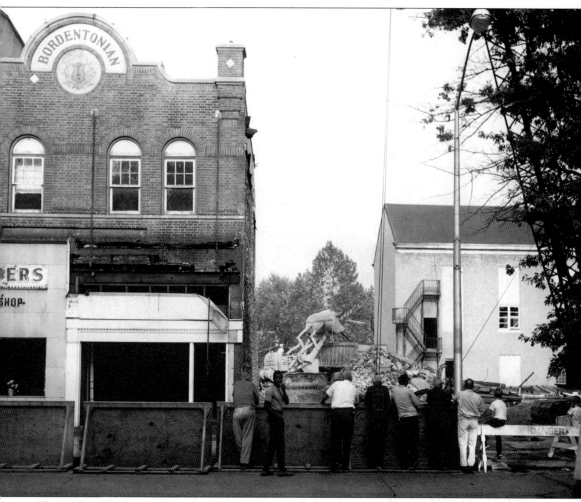

The Embers Sandwich Shop, serving charcoal-broiled foods, is the next building to come down during the East Church Street urban renewal project of the mid-1960s. Even the movie theater was torn down. The project area was bounded by Farnsworth Avenue, East Church Street, Second Street, and Railroad Avenue. It later included the 200 Block on the east side of Farnsworth Avenue. There was much controversy over the changes made from this $500,000 idea. Two parking lots, new town houses, and new apartments were the end result. Many people still talk about the businesses that once lined the avenue. (Photograph courtesy of Bill Hensley, photographer.)

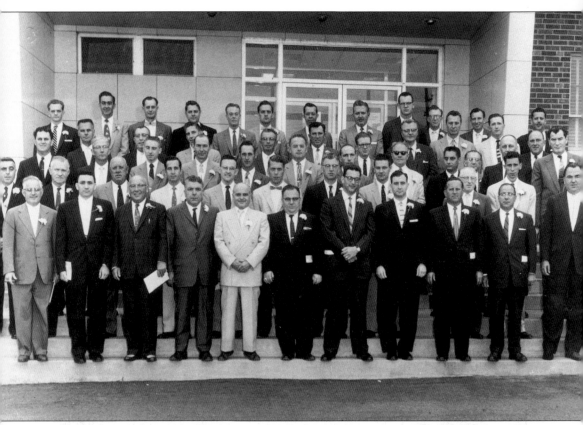

The charter members of the Bordentown Benevolent and Protective Order of Elks No. 2085 are shown here in the early 1960s. An Englishman in the theatre and entertainment field, Charles Vivian started the social group known as the Jolly Corks in New York City in the 1800s. It evolved from helping a member's family in need and progressed to raising money for children with disabilities, youth projects, and recreational programs for patients in veteran hospitals. A national observance came from their use of June 14 as Flag Day. The Elks continue to help people in many situations of need, but they specialize in helping children. (Photograph courtesy of Evelyn Appleby.)

# *Eight*

# YOUTH

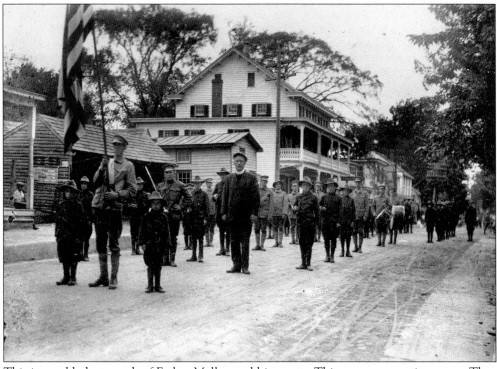

This is an old photograph of Father Malloy and his scouts. This was a very active group. They went camping, on picnics, and marched in parades along with learning the things that boys need to learn. Bordentown has long loved its parades and always has youth represented. (Photograph by James L. Glancey, courtesy of Francis Glancey.)

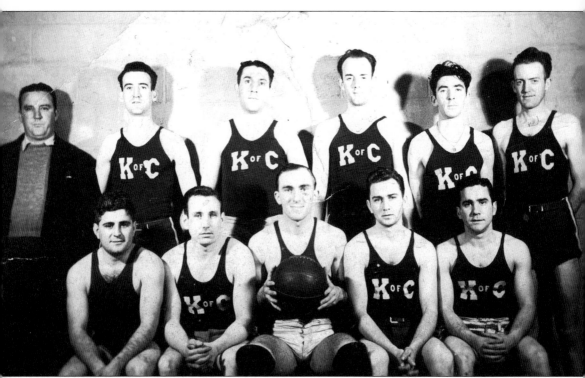

The Knights of Columbus-St. Mary's basketball team is shown here in 1934. Pictured, from left to right, are: (front row) Neptune Mercantini, William McDonaugh, Walt Johnson, Pete Clark, and George Spundarelli; (back row) unidentified coach, Jimmy Donahue, Ed Donnelly, Jack Maley, ? Mathews, and John Kelly.

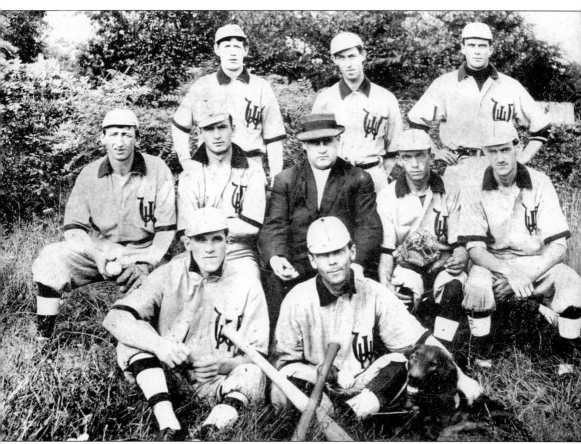

Bordentown has always encouraged organized recreation, and baseball teams have long been a popular sport here. In this undated photograph are, from left to right, the following: (front row) George Erickson and George Hesley; (middle row) Charles Sadler, Jim Valentine, manager John Church, Nick Hesley, and John Scyples; (back row) Frank Ferry, Andy Williams, and Danny Cottrell. (Postcard courtesy of Gloria Spundarelli.)

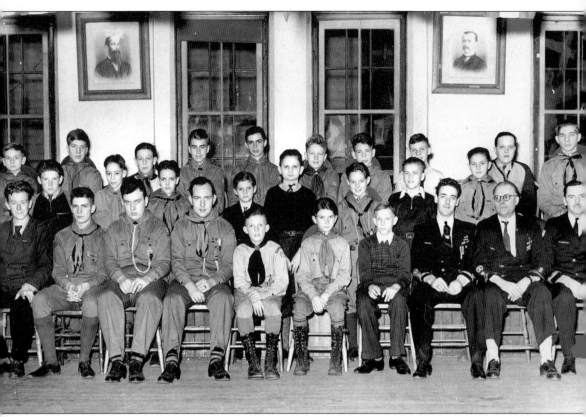

The Boy Scouts of America started in 1910. Troops were organized in Bordentown in 1925 and are a very popular activity for the boys, even today. The churches in town have always offered room for the youth to gather for their meetings. Troop 13 is represented here at the First Baptist Church in this undated photograph. (Photograph courtesy of J.C. Platt.)

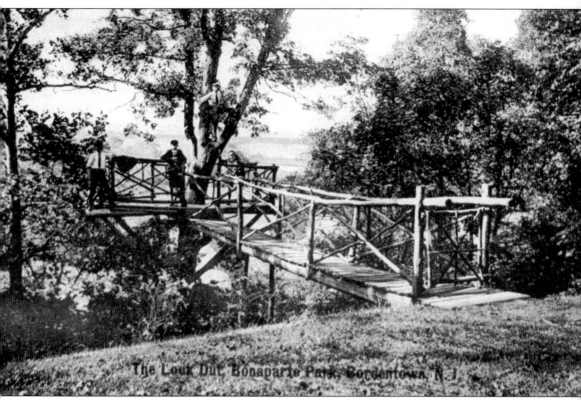

The Look Out, Bonaparte Park, Bordentown, N. J.

Known as the Look-Out at Bonaparte Park, the walkway looks out over the Delaware and Raritan Canal and Delaware River. In this 1930s photograph, there are three lads on the walkway and one up the tree. The Point Breeze Park, as it has been called since Joseph Bonaparte lived here, has fascinated young people wanting to explore its tunnels, woods, creek line, and trails. Bonaparte brought gardeners and craftsmen from Europe to create his gardens and fountains. The park was known as exquisite in its earlier history. Henry Beckett bought the Bonaparte property in the late 1800s. Harris Hammond was the next owner in the 1920s, and then the Society of the Divine Word purchased the estate in 1941. (Photograph courtesy of John McCoy.)

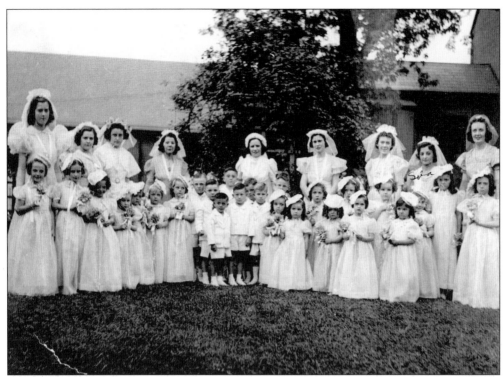

This photograph is of the Sodality Club of St. Mary's Church and School. After a girl graduated from the eighth grade she could belong to this social group. Every May, there would be a crowning. (Photograph courtesy of Elsie and Sola Valentini.)

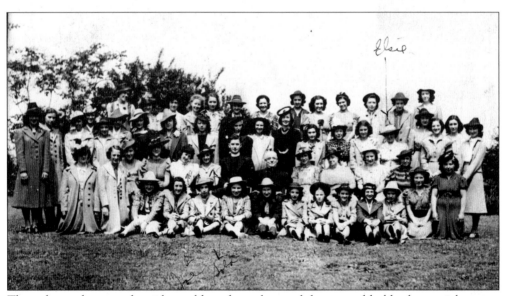

Through out the year, the girls would produce plays and dances and hold other social events. The club went out of existence some time ago. In the center of the photograph sits Father Whalen and Father Donovan. The photographs date from the late 1930s. (Photograph courtesy of Elsie and Sola Valentini.)

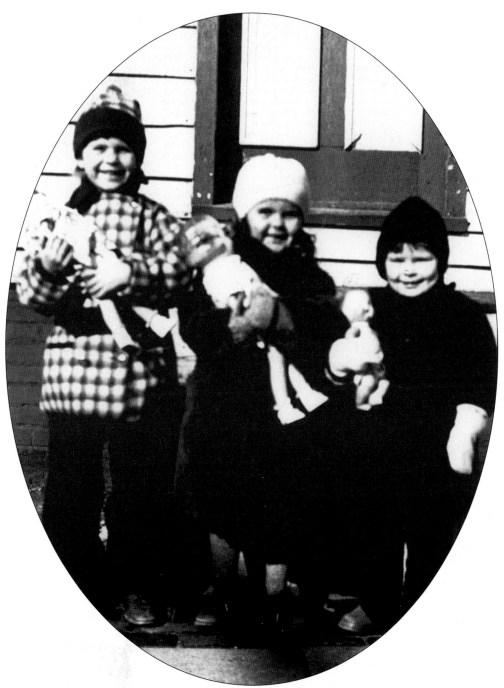

Growing up on Mary Street in 1936 in Bordentown meant having lots of kids around of all ages to play with. Here, the Cremer sisters are all bundled up with their dolls in arms, ready to play house. Seen here are, from left to right, Janet Cremer (Lynch), Claudia Cremer (Lange), and Elsie Cremer (Newborn).

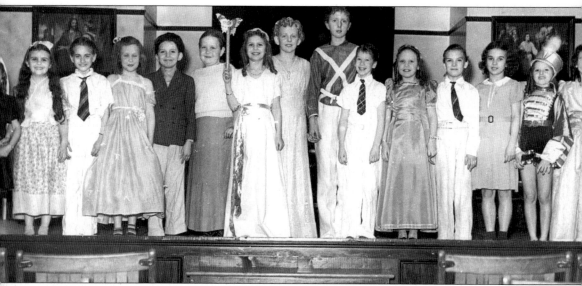

The First Baptist Church of Bordentown has long been the center for youth activities. Here, they have the Brownie group performing the *Cinderella* play in 1940. These events created wonderful memories that everyone carries with them and brings out once in a while, like treasures. The actors, from left to right, are Rita Mack, Claudia Cremer, Ruth Dickson, Barbara Asson, Betty Exner, Betty Letts, Janet Cremer, Elizabeth Oberholzer, Barbara Bozarth, Jeanette McNinney, Betty Ann Leaver, Louise Bozarth, Betty Gibbs, Glenna Bunnick, and Peggy Stecker. (Photograph courtesy of Janet Cremer Lynch.)

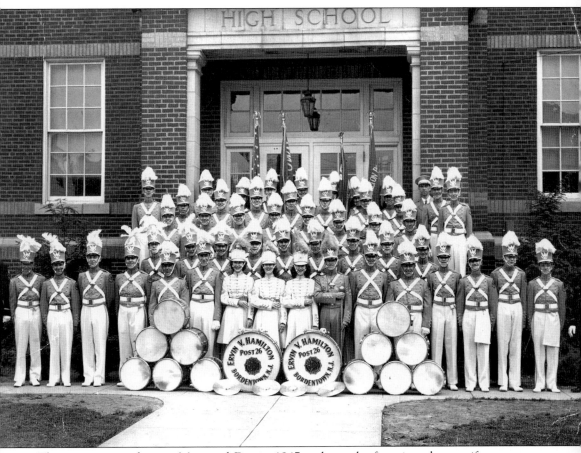

The picture was taken on Memorial Day in 1947 and was the first time these uniforms were worn. In addition to the band, two American Legion members are shown. On the left is Bob Parker, and on the right is Hewling Lamson. The Ervin V. Hamilton Post 26 was formed in 1919 to honor the first Bordentown boy to lose his life in World War I. The band plays and marches in area parades and performs in memorial services. Some of the names listed are Koffman, Massari, Eckman, Hall, Cremer, Rhubart, Lamson, Heupal, Rowley, Lovejoy, Price, Tunney, Blinstein, Morris, Archer, Campell, Haas, Mathews, Hicks, Lynch, Platt, Tyrel, Keating, Stone, Valentine, Feaster, Page, Minch, Mallery, Thorn, Loretangeli, and Dennis. (Photograph courtesy of Janet Cremer Lynch.)

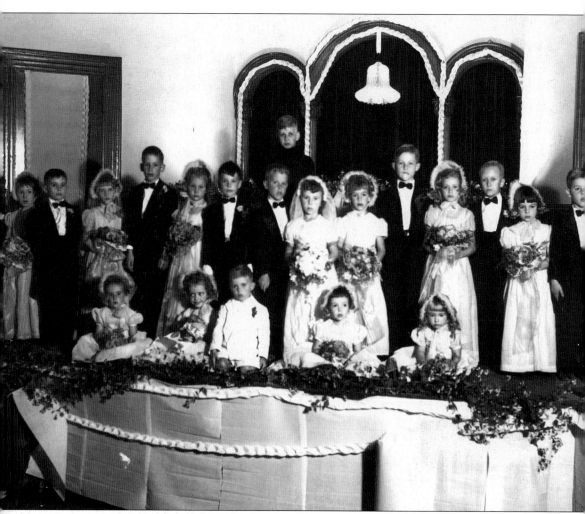

There are serious expressions on the familiar faces of the children dressed up for the "Tom Thumb Wedding" at the First Baptist Church of Bordentown in 1946. Pictured are, from left to right, the following: (front row) Myra Swartz, Ann Jobes, Bert Rogers, Elsie Robinson, and DeAnn Petarscity; (second row) Gary Bell, Pearl Ann Newman, Bobby Knox, Gloria Davis, Neil Forsyth, Paula Hamilton, Neil Sheppard, Paul Rogers, Nancy Nelson, Peg Forsythe, Keith Ellis, Sally Blakesley, Jack Golden, Joyce Sheppard, and Tom Hewitt. Standing in the rear is Albert Blakeslee. (Photograph courtesy of First Baptist Church.)

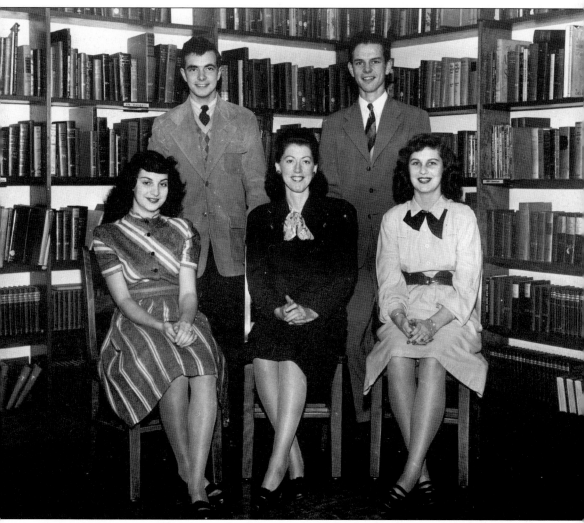

Being an active part of the class and volunteering in high school is a very important portion of going to the last years of public school. The clubs and activities help to form social skills that are necessary in world. This 1948 photograph shows the senior class officers at MacFarland High School. They are, from left to right, Isy Parikas, treasurer; Martin Straussfogel, president; Ella Hamilton, class advisor; Bill Pigott, vice-president; and Janet Cremer, secretary. When the new Bordentown Regional High School was built in the township, combining schools for the area, MacFarland became a junior high school. (Photograph courtesy of Janet Cremer Lynch.)

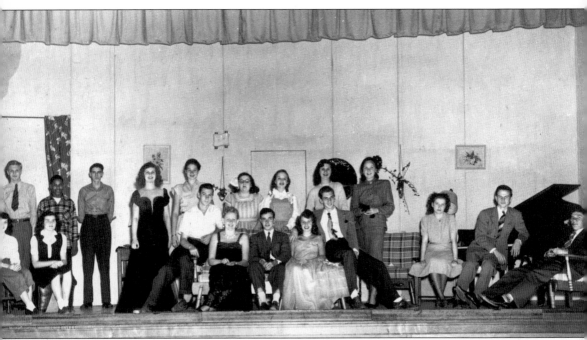

These were fun times when this troupe gathered together in 1941 to act out *A Date with Judy* for the senior play at MacFarland High School. Sometimes, you wonder whether it is more fun at the rehearsals before the play, the actual performing of the play, or the party after the play. Seen here, from the left to right, are Isy Parikas, Ken Andrews, Peggy Stecker, Leroy Banks, Bob Gabel, Janet Cremer, Doris Stevenson, Herb Swaim, Elizabeth Oberholzer, Patsy Sheedy, Martin Straussfogel, unidentified, Lois Aaronson, Glenna Bunnick, Joe Harbour, Doris Young, Frances Kurdzill, Jeanne Layton, Bill Pigott, and Ed English. (Photograph courtesy of Janet Cremer Lynch.)

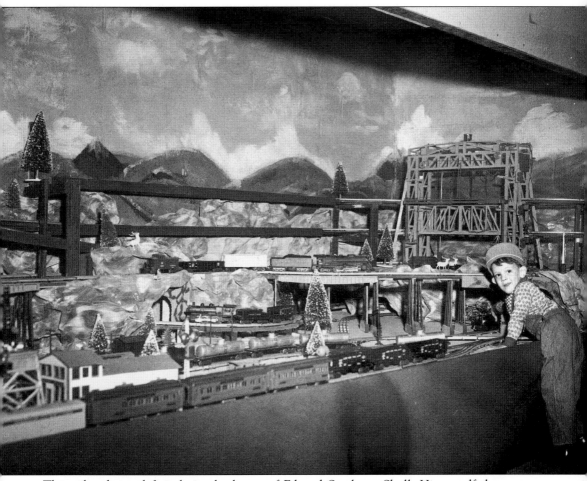

The railroad was definitely in the bones of Edward Steelman Sholl. His grandfather was a fireman on the *John Bull*, his father, Harold A. Sholl, was an engineer that pulled the *Nellie Bly*, and Ed was known nationally for his railroad hobby. The house he and his wife Mildred lived in was built and occupied by Benjamin F. Jobes, the last engineer of the *John Bull*. Seen here is part of his layout of railroads set up in his railroad museum. He also built a $1/16$ scale model of the Pennsylvania Railroad's K4 steam locomotive and a model of the *John Bull*. The models are presently at the Bordentown Regional High School. (Photograph courtesy of John McCoy.)

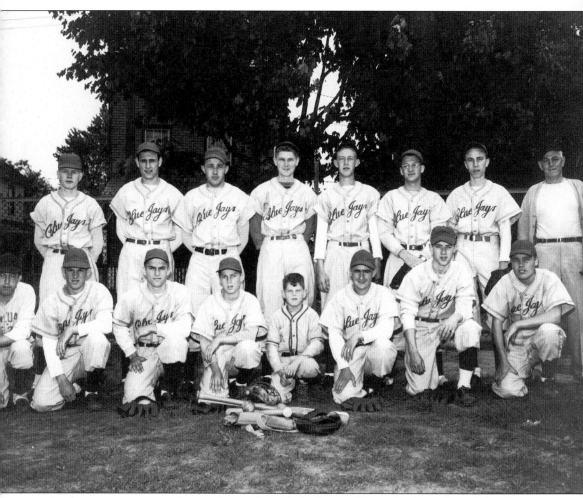

Bordentown guys seemed to make good baseball players. They also have fun while playing. Shown here is the Bluejays baseball team in 1948. The members are, from left to right, as follows: (front row) Bill Felter, Tinky Platt, Harold "Sonny" Elliott, Bob Colby, Gary Colby, Ray Carter, Jackie Platt, and Jack Colby; (back row) George Grove, Fred Billingham, Kermit Asson, Bill Brehet, Del Davis, Harold Million, and Tommy McCale. Mr. McCale, on the end, was the coach and sponsor. (Photograph courtesy of J.C. Platt.)

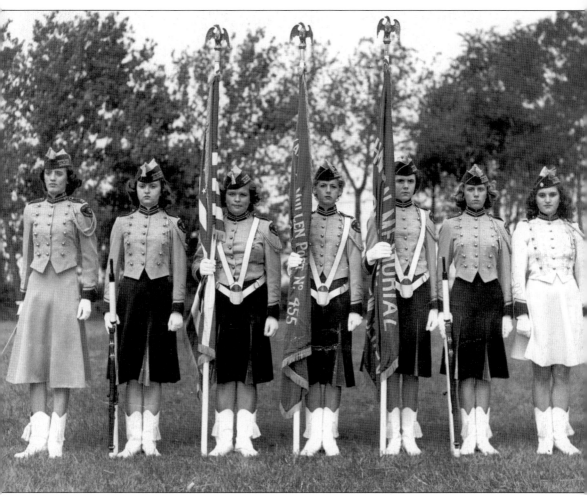

The Johnson Memorial All-Girls Cadets Color Guard stand at attention during a performance in 1953. Seen here are, from left to right, Jeanette Dickson, captain; Sylvia Karrer, lieutenant; Ann Stanton; Catherine Horner; Elaine Bleistein; Louise Thomas; and Carol Apoldite, second majorette. The Johnson cadets were formed by Edna W. Johnson in 1949. They were named in memory of Charles and William Johnson, who lost their lives in an automobile accident in 1947 while returning from marching in a parade in Mount Holly. The cadets marched in many parades and won many competitions and trophies traveling as far as Miami, Florida. Ralph Stone was assistant director of this all-volunteer group. (Photograph courtesy of Ann Stanton Price.)

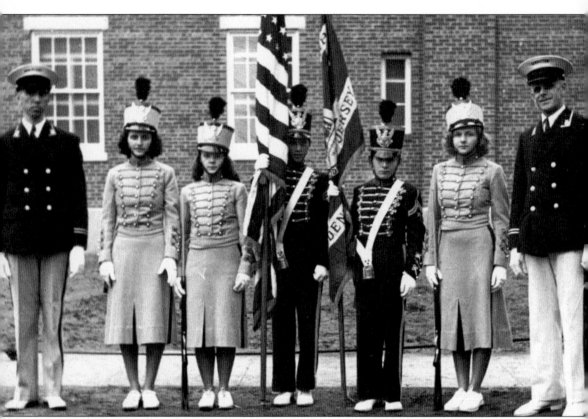

The King City Cadet Color Guard is lined up here to take their place in a Bordentown parade. Over the years, Bordentown has held many parades with many different marchers from the military, the civic groups, the firemen, and high school bands. The color guards always receive special attention. The King City (named for Joseph Bonaparte) cadets started out as an all-boy group, but later invited the girls to join them. (Photograph courtesy of Evelyn Appleby.)

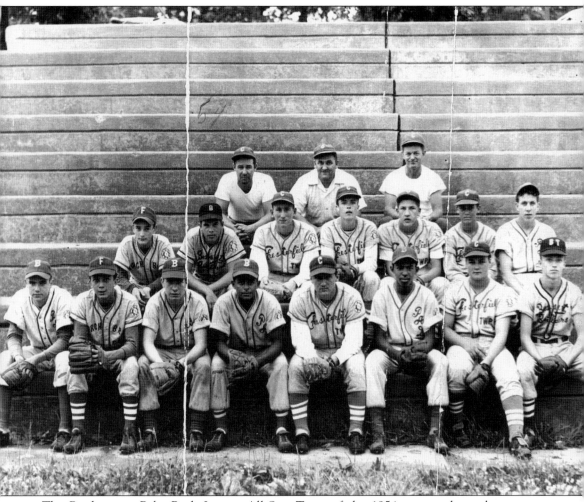

The Bordentown Babe Ruth League All-Star Team of the 1954 season, shown here, was comprised of players from the four teams in the league. The league standings were Chesterfield (first place), Bordentown City (second place), Fieldsboro (third place), and Bordentown Township (fourth place). This was the only team to date to play for the state title. The championship game was lost to River Edge/Ordell. An impressive motorcade of several buses and vehicles loaded with fans drove to Atlantic City. Pictured here are, from left to right, the following: (front row) Bob Parker, John Borbi, Dick Murphy, Tom Matlock, Dave Lebak, Dick Ganges, Harry Lawyer, and Ron Kolwicz; (middle row) Donald Sterling, Harry Forman, David Russell, Fred Holloway, Jerry Parker, Larry Reed, and Joe Foster; (back row) George Lesnak, Warren Russell, and Nick Oshinski. (Photograph courtesy of Larry Reed.)

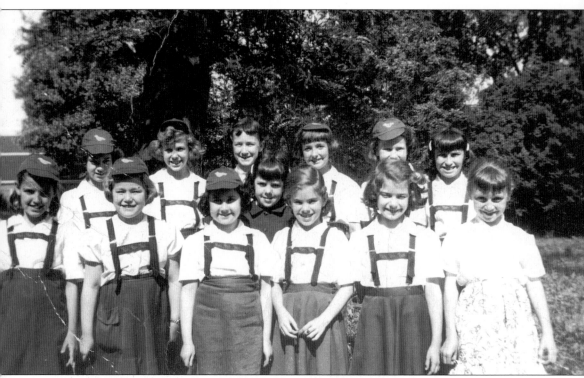

This is the 1954 Bluebird Group at Gilder Field. The Bluebirds were introduced in 1913 as a younger division of the Campfire Girls. In 1989, the group changed its name to Starflight and included boys. Pictured here, from left to right, are: (front row) Sally Miller, Marion Weissman, ? Mathews, Janet Foulks, Jackie Weaver, and unidentified; (back row) Sandy Newman, Dorothy Stinner, unidentified, Elsie Robinson, Sandy Derby, and Mona Samsel. The Gilder House and grounds were given to the city by descendent Rodman Gilder in 1926. The grounds were set aside for a park and community area. Gilder Field is used by many of the youth groups. Competitions, picnics, and fireworks on the Fourth of July are based at Gilder Field. (Photograph courtesy of Sally Miller.)

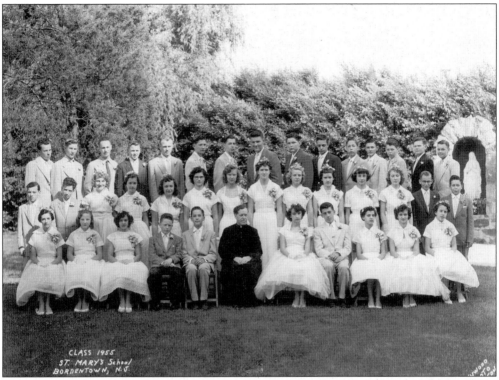

The 1955 eighth-grade graduation class of St. Mary's School gathers here in celebration. This was a proud day for parents and students alike. The highest grade in the Catholic school in Bordentown was the eighth grade. For a Catholic high school education, the kids had to go to Trenton. As was traditional, the girls were dressed in white and the boys in suits or sport jackets. Signatures from many of the classmates, shown below are written on the back of the photograph, as was the fad of the day. (Photographs courtesy of Leona Kelly Zendrosky.)

It was the tradition and the joy of the eighth-grade graduates to collect as many signatures of their classmates as possible on the back of their class photograph. This was a time when several of the class friends would go separate ways. Some would go on to the Catholic high school in Trenton while others would go the public William MacFarland High School in Bordentown.

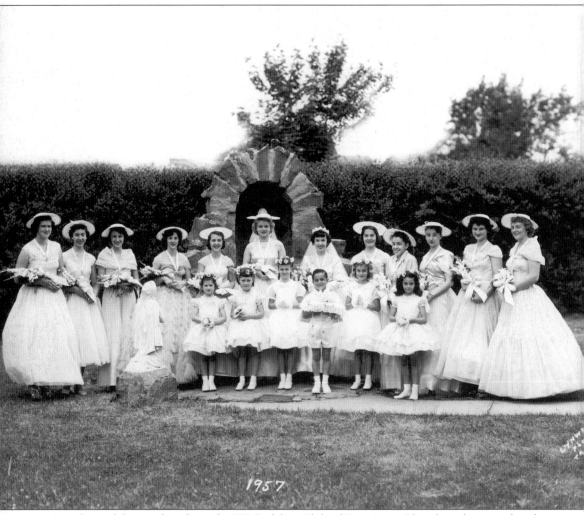

1957

Members of the newly reformed 1957 Sodality Club of St. Mary's Church gather together for the traditional May crowning of the Blessed Virgin. The youngsters in the front row are unidentified, but the girls in the back row are, from left to right, Betty Lou Walters, Regina Mezzei, Barbara Shard, Leona Kelly, Kathy McGowen, unidentified, Pat McKee, Judy Lynch, Mary Wagner, Jackie McDonaugh, Joyce Bertothy, and Virginia Haines. (Photograph courtesy of Leona Kelly Zendrosky.)

Another exciting event for the teens in 1957 were the Johnnie Norcross block dances. Bordentown's Johnnie Norcross was an accomplished pianist and organist. He often was invited to play on the radio. His band played live for the kids once a week. The teens would dress up and gather at the Hope Hose (before the building was erected) on West Burlington and Willow Streets. Music floated through the air as the kids danced the night away. Shown here, the committee members are, from left to right, Judy Mercantini, Ellen Kelly Tell, Jane McDonaugh Rooney, Jackie McDonaugh Reed, Leona Kelly Zendrosky, and Ginnie Flynn Haines. (Photograph courtesy of Leona Kelly Zendrosky.)

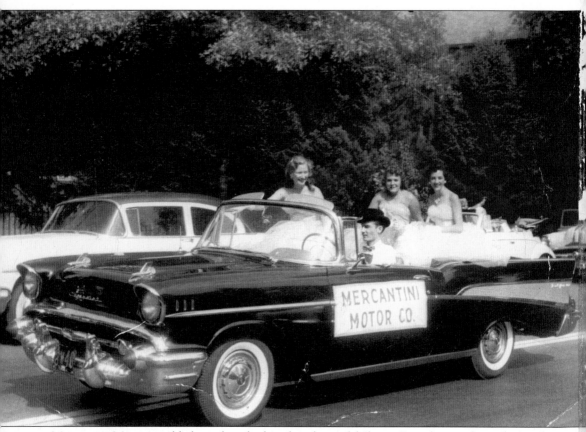

Mercantini Motors could always be relied on for a beautiful "loaner" car for parades and special events. In this photograph is a beautiful 1957 Chevrolet on loan from Mercantini Motors for the great celebration of the 275th anniversary of the City of Bordentown. The car is carrying local lovelies vying for Miss Bordentown title. The way to win this contest was to buy votes! But not to fret, this was a fundraiser. So it was Betty Ann Abraham, who sold the most votes, that won. (Photograph courtesy of Leona Kelly Zendrosky.)